**Lotta**
Jansdotter

# LOTTA PRINTS

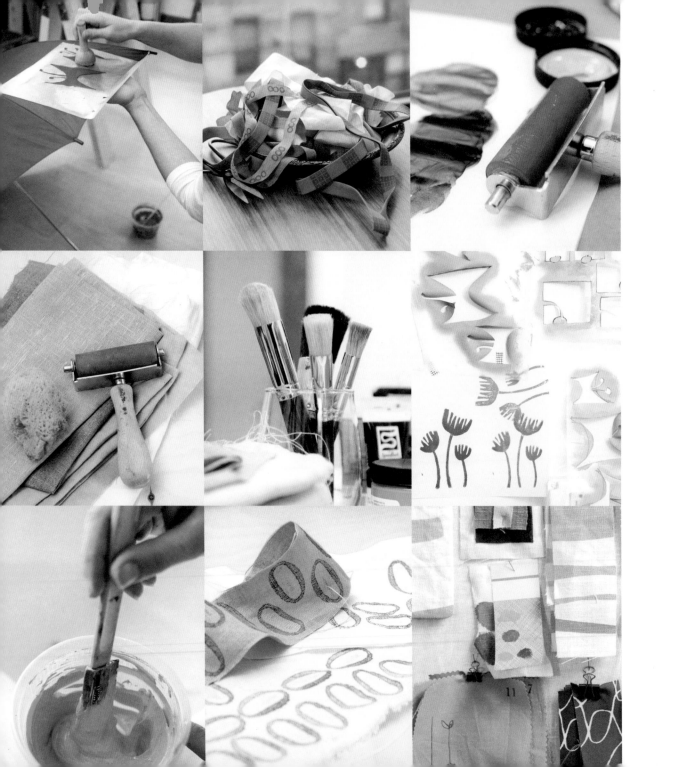

**Lotta**
Jansdotter

# LOTTA PRINTS

How to Print with Anything, from Potatoes to Linoleum

By Lotta Jansdotter

Photographs by Jenny Hallengren

CHRONICLE BOOKS
SAN FRANCISCO

Library of Congress Cataloging-in-Publication Data

Jansdotter, Lotta.

Lotta prints : how to print with anything, from potatoes to linoleum / by Lotta Jansdotter ; photographs by Jenny Hallengren.

    p. cm.

ISBN: 978-0-8118-6037-6

1. Handicraft. 2. Relief printing.  I. Title.

TT857.J35 2008

745.5--dc22

                                    2007027213

10 9 8 7 6 5 4 3 2 1

Chronicle Books LLC

680 Second Street

San Francisco, California 94107

www.chroniclebooks.com

I would like to dedicate this book to my lovely and simply wonderful
friend, Jenny.

Tack vännen!

# CONTENTS

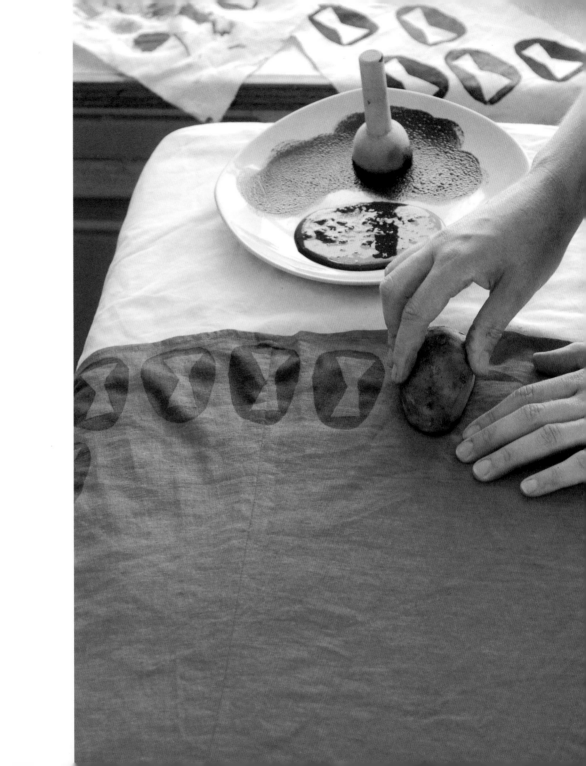

# INTRODUCTION

As a girl growing up in Sweden, I loved to draw. I drew flowers, princesses, landscapes, more flowers, critters, plants, and even more flowers. I drew in my notebooks, on paper napkins, made my marks in clay, and decorated my wardrobe doors and chair with my motifs. I also had several pen pals around the world, and I made sure to adorn the envelopes with my illustrations and designs before dropping them in the mail.

In my twenties, I was still drawn to the creative arts, but uncertain about what I wanted to do for a living. I took classes in painting, sculpture, jewelry, and ceramics. In every medium I tried, I found a way to incorporate my motifs and patterns—that was truly the aspect of creating I enjoyed most. When I took my first screen-printing class at a community college, I immediately knew I had found MY medium. It just clicked . . . I loved screen printing! I could print my drawings and mix my own colors. It was a bit technical and required some planning, which I enjoyed. The best part: I could print multiples of my drawings. When I realized that I could quickly produce several pieces with the same design, a whole new world opened for me.

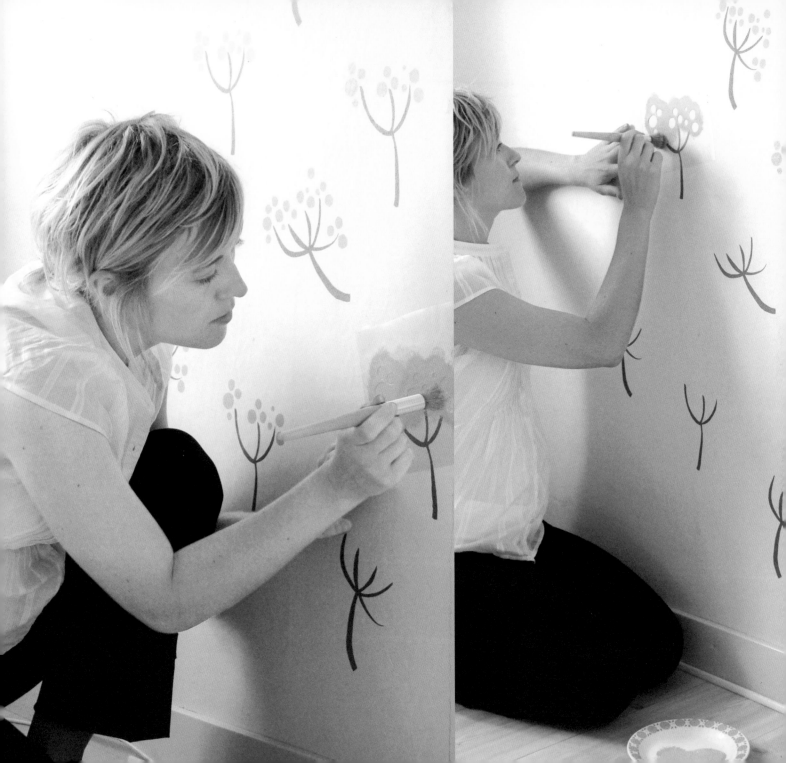

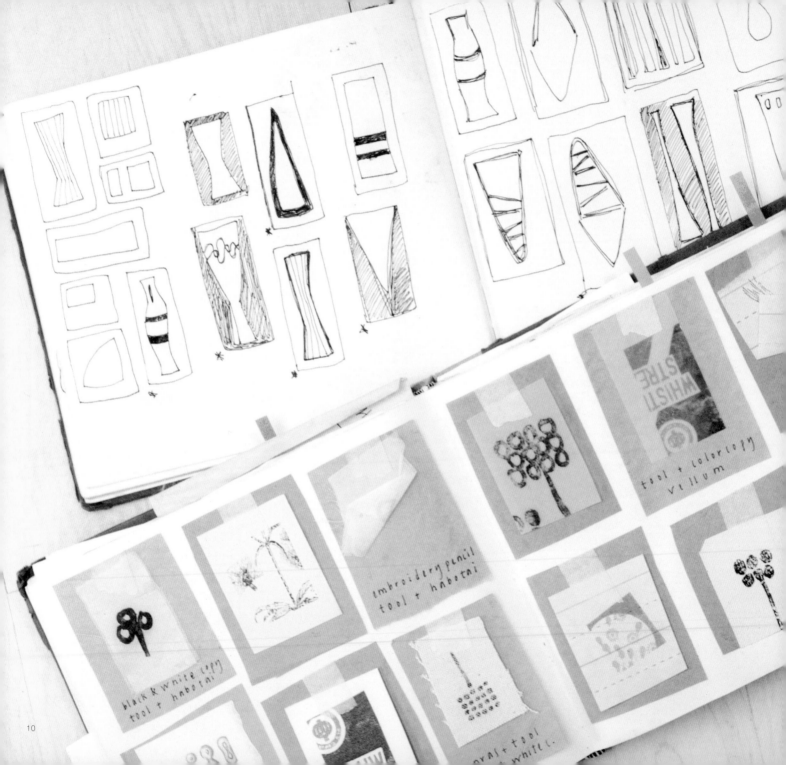

I decided to quit school, and I moved to San Francisco to pursue my own business as a designer. I set up shop, printing in a closet in the basement. It really was that small! I would clean my screens with the hose outside next to the garden. I put together a small collection of pillows. I would screen my own product tags, labels, business cards, and other marketing material. And that was it: the company Lotta Jansdotter was born.

That was well over 10 years ago, and since then I have continued to explore different ways to print and different surfaces to print on. When I started, I called myself a textile designer, but I quickly found that too limiting. My designs adorn so many more surfaces than fabric: stationery, ceramics, leather, shower curtains, and product packaging, to name a few. So, these days I call myself a surface designer.

And you can, too! Whether you are interested in starting your own independent label of printed goods or simply want to explore a new art medium, I hope this book will entice you to start printing. The materials and equipment needed are for the most part inexpensive and easily obtained or improvised. For instance, a spoon or a rolling pin can be used as an effective substitute for a printing press. It's true! You do not need any prior experience or knowledge to create the projects in this book. They are that simple and basic.

This book is filled with simple step-by-step instructions, various kinds of projects, methods, resources, and information, but mainly it's filled with ideas and inspiration. I encourage you to experiment with different ways to print and different materials and items to print on. I have discovered many methods and techniques that work for me by experimenting with different combinations of inks and materials. There is really no wrong way.

I hope that these photos, drawings, and easy instructions will inspire you to put your own original marks on paper.

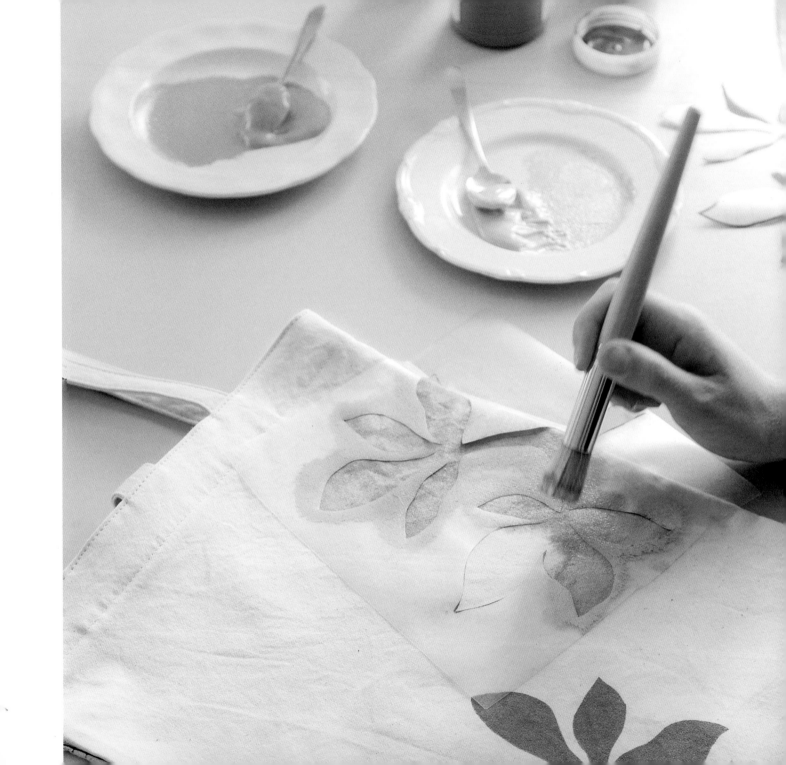

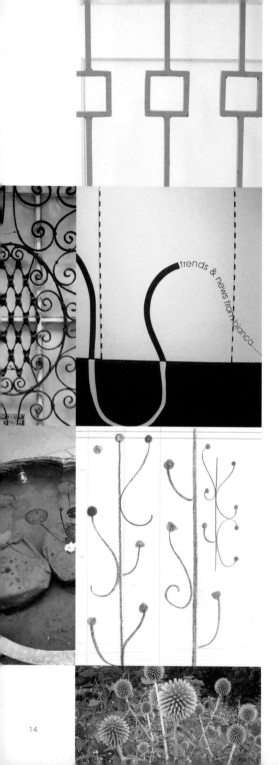

trends & news from bianca......

# INSPIRATION

When people talk to me about my work and my designs, I am most frequently asked this question: "Where and how do you get your inspiration?"

I find that question very hard to answer simply with words, and my answer sounds so cliché: "Everywhere."

However, it is truly so. Everywhere you look, you'll find patterns and motifs surrounding you; you just have to "see" them. To help you understand how I see things, I have included snapshots I've taken of things that inspire me and some of the drawings that they inspired. Throughout this book, you will find my inspiration photos and notes from my sketchbooks. This way you can see how my process works and how I get inspired. My hope is that I'll help you a wee bit to be inspired by "everything" as well!!

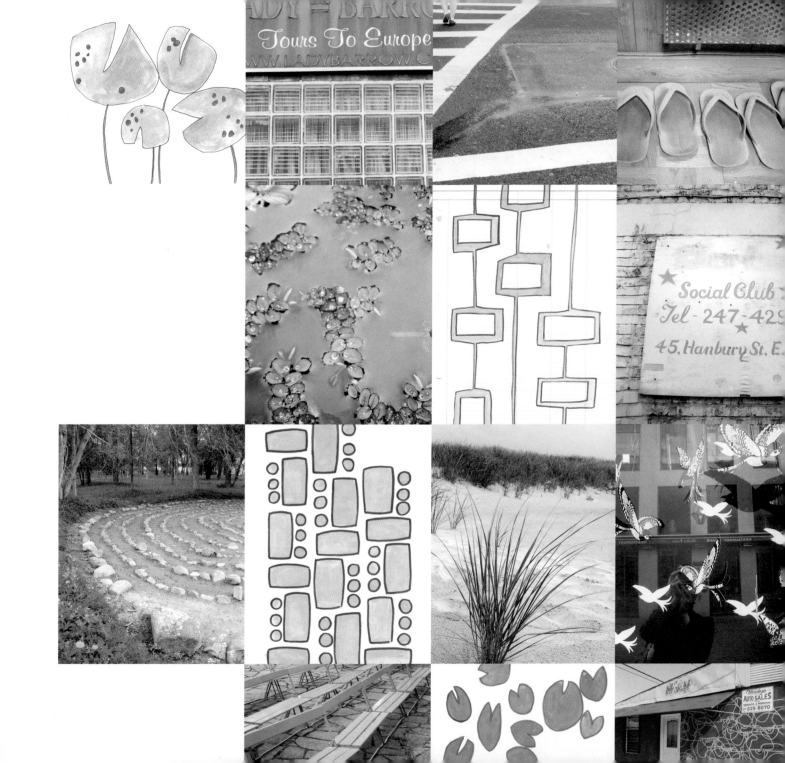

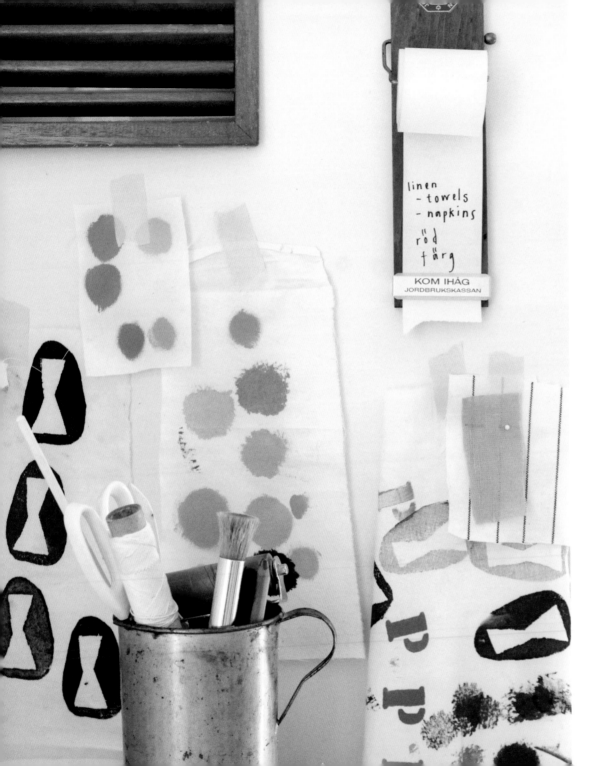

linen
- towels
- napkins

röd
färg

KOM IHÅG
JORDBRUKSKASSAN

# BEFORE YOU GET STARTED

Before you get started, I want to share some thoughts and tips with you. Printing requires a few essential tools and props. When you start printing, you'll want everything close at hand. To help you set up, I've outlined the basics here.

## SETUP

You can set up your printing space anywhere, as long as you have a flat surface to print on. I have printed on my kitchen counter, on the living room floor, and even once in a bathroom. But if you really take to printing and find that you are doing a lot of it, I strongly recommend that you position your printing surface at a good height in relation to your body. You do not want to bend over in weird positions repeatedly. . . . Please take care of your back!

## YOUR PRINTING SURFACE

Make sure that your surface is flat and even with no bumps or holes. Hard surfaces work best for printing on paper. Slightly padded surfaces work best for printing on fabrics, but don't choose anything too soft.

If you are printing on fabric, you can easily make a padded surface that's portable and can be stored away when you are not using it. Here's how:

1 Take a sturdy board (the size is up to you) and wrap some flat batting around it. You can find batting at fabric or craft stores.

2 Cover the batting with canvas fabric and stretch it tight around the board.

3 Using a heavy-duty staple gun, secure the fabric to the back of the board, being sure that you fold the canvas nice and flat so the board does not become wobbly. Voilà!

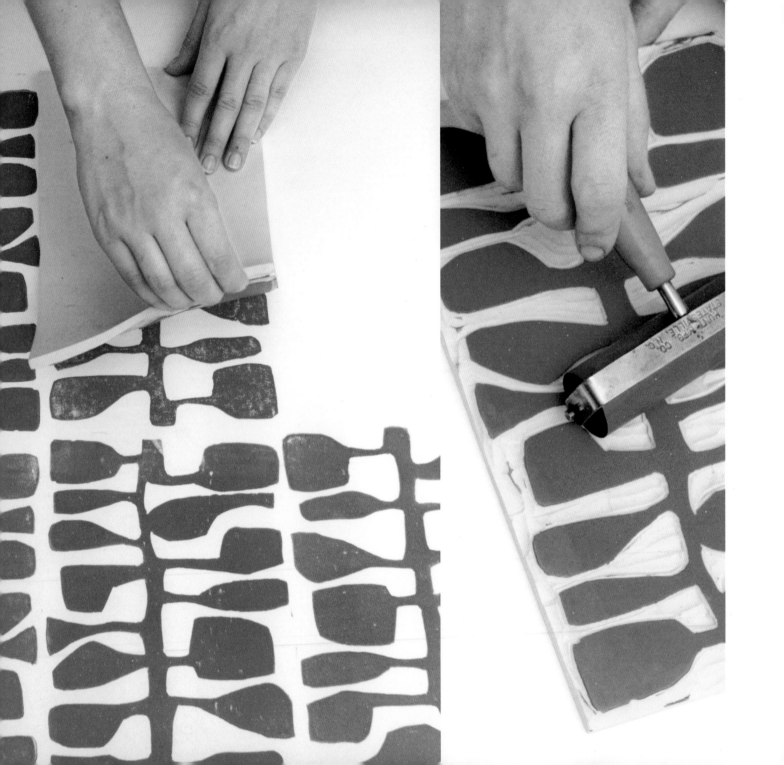

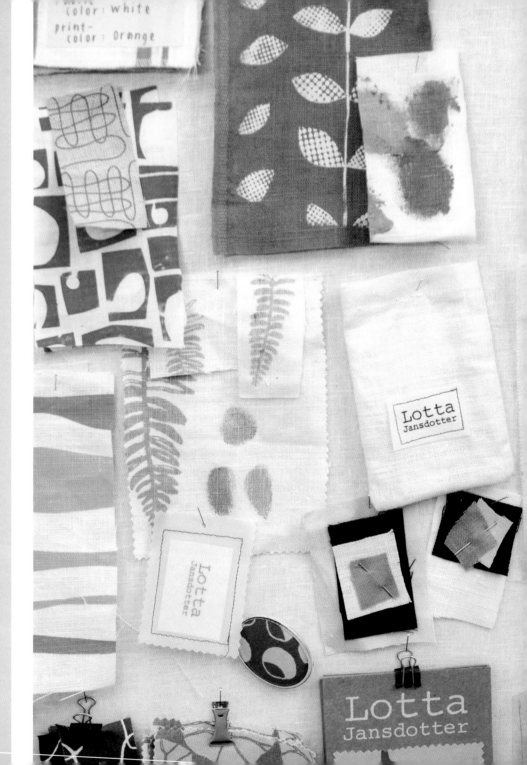

## MATERIALS TO PRINT ON

You can print on SO many different materials: paper, plastic, fabric, wood, rubber, and cork, to name just a few! I hope that you will experiment with all kinds of materials. The only thing to keep in mind is that you should always make sure you have extra material on hand for mistakes, because there will almost always be mistakes. (And that's okay . . . sometimes the mistakes are happy ones and you might find that you really like them.) For example, if you plan to make 20 cards, you will want to add five or six extra cards for mistakes.

It's also helpful to practice printing on scrap materials before you get started on your "final" materials.

## INK

For every different material out there, you'll find the appropriate ink. There are many different kinds of ink and paint suitable for printing, and you will find many options. When you're starting out, you may want to use standard block-printing ink while block printing, and fabric paints when printing on fabric. But as you get more comfortable with printing, you may play around more with the inks, and I sincerely encourage you to do so. So, go ahead: try screen-printing or block-printing ink when stenciling. You'll discover different textures and results; it all depends on what you print on, the nature of your design, and the final purpose of the material you print on. The ONE medium I would be careful about is screen printing: use ONLY screen-printing inks while screen printing, just to be safe, as you do not want to ruin your sensitive screen.

Make sure to read all the instructions on the ink packaging for information on whether the ink is water-based or not, permanent or water-soluble, and intended for fabric or paper. This kind of information will help you know how to clean your tools off and care for your finished prints.

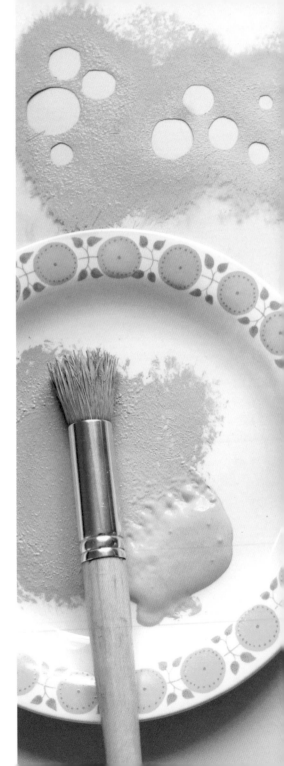

## OTHER USEFUL THINGS

• Water: It is really helpful to have a faucet close by. I don't know about you, but I am a really messy printer, so having access to running water is necessary. If that's not possible, keep a spray bottle filled with water on hand.

• Scrap Paper: Keep newspaper, and scrap paper close by while printing to rest messy tools on, to wipe blobs of inks off the floor, and so on. Rags and old fabric will also work.

• Brayer: A brayer is a small hand roller used to spread ink thinly and evenly.

• Apron: Wearing an apron or old clothes when you print is a good idea.

• Hair Dryer: A hair dryer can be used to dry off prints, blocks, screens, and stencils. I love instant gratification: the faster I see results, the better!

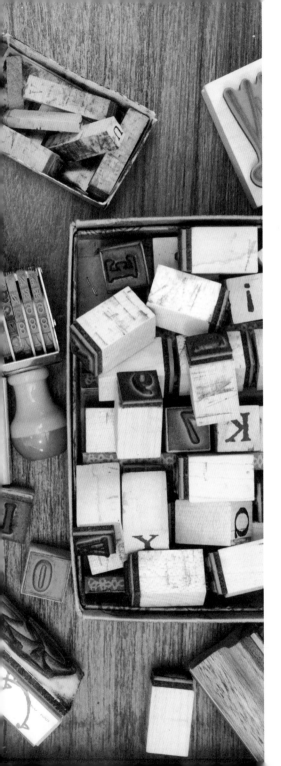

## TIPS ON SETTING UP

• Have all your supplies and materials ready before you start printing.

• Make sure ink jars are open and all the inks are mixed before you start printing, and have spatulas on hand if you are planning to do some custom colors yourself.

• Any tools and all the paper or fabric you want to print on should be close by.

Setting up takes a little while and might be a pain, but it makes for better, smoother, easier, and FASTER printing. Well, I think that's it! Let's get started. . . . Don't forget to have fun, be flexible, and to experiment to find your own favorite methods for designing and printing.

# RUBBER-STAMP PRINTS

This is certainly the easiest printing process of all. It offers almost instant gratification. All you need to do is go out and buy the stamps and ink pads and get started. Because this method is so easy, it's ideal for ambitious projects, such as wedding invitations or holiday cards.

You'll find an infinite number of different stamps on the market, and almost as many different colors of stamp pads. You can find rubber-stamp supplies in well-stocked stationery stores, arts and crafts stores, and also online. A very thrilling alternative is having stamps made from your own drawings and designs. [See Resources on page 100 for more specific information.]

Rubber stamps work beautifully on all sorts of paper. Don't stop at paper though; with a little bit of imagination and a touch of perseverance, you can print on many other surfaces as well. Why not print on T-shirts, on a fabric lamp shade, or on leaves?

## WHAT YOU NEED

– Rubber stamp
– Ink pad
– Paper or fabric

## WHAT YOU DO

You hardly need directions. Just press your stamp first on the ink pad and then on your printing surface.

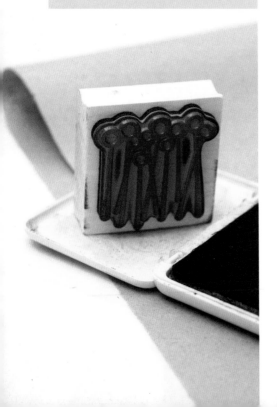

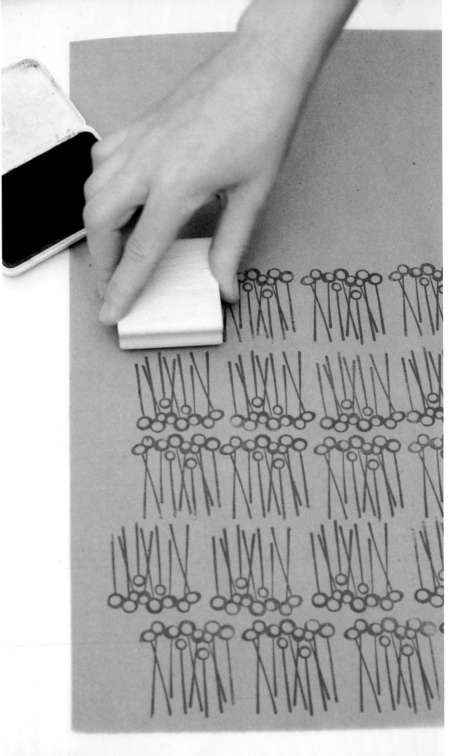

# TIPS

* It is a good idea to practice stamping on scrap paper first. With some stamps, the edge picks up ink and leaves a mark. If this is the case, wipe that area clean each time before stamping.

* On curved surfaces, use a rolling motion, stamping a portion of the design before gently lowering the rest of the stamp to the surface.

* Repeat the stamp or a few stamps in a series to create a pattern or border.

* To clean the rubber stamp: Rinse it with warm water, and dab excess water off with a cloth or paper towel. Set the stamp aside and let it air-dry completely before using it again.

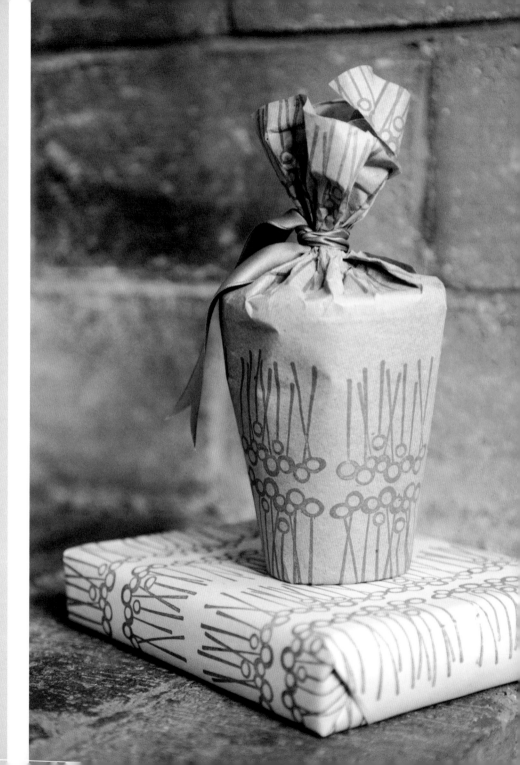

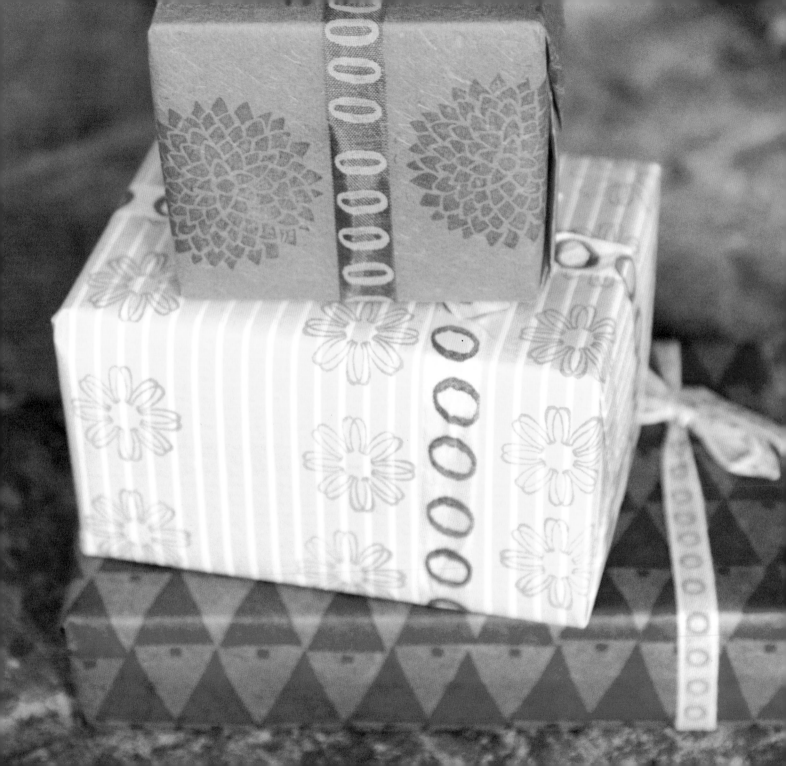

**WRAPPING PAPER AND RIBBON/**
Make the simple act of wrapping
gifts a little more special by using
your own stamped gift-wrap and
ribbon. Take the opportunity to play
around with different ink colors and
papers—the combinations are
endless. You can use fancy
handmade paper or simple craft
paper: the choice is yours. When
printing ribbons, you will get a more
successful result by printing on
smooth, natural materials, such as
silk or cotton ribbon.

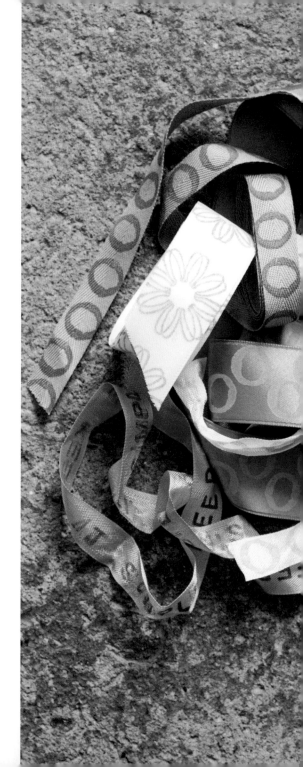

**LABELS/** Making your own sticky labels is not only easy, it is also very fast. You can quickly transform plan office stickers into pretty and decorative labels. Use your new labels on envelopes, gifts, journals, books, and tins.

**PANTS/** You can dress up any garment with some fabric paint and a rubber stamp. Try stamping a border around the neck of a T-shirt or add some detail to a pair of cargo pants. Make sure that you use permanent ink. Do a test on some scrap fabric first.

# IRON-ON PRINTING

With the help of an ink-jet printer, you can create all sorts of iron-on projects in a jiffy. It may be one of the easiest ways to transfer a design from one surface to another—no need for time-consuming preparations or messy inks. Best of all, you can print your favorite drawings, photos, or magazine clippings onto all kinds of items: T-shirts, pillows, curtains, baby onesies. . . . The sky is the limit!

Because you'll be using a hot iron, I suggest that you use only natural materials, such as cotton, linen, or silk. The heat of the iron will likely damage synthetic fabrics.

No longer do you have to search for iron-on transfer paper in select art and craft stores. Nowadays, you can easily find it in any well-stocked office-supply store or online.

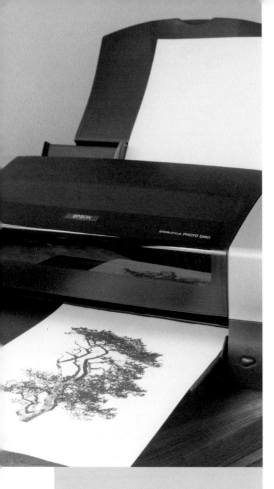

## WHAT YOU NEED

- Iron-on transfer paper
- Ink-jet printer
- Sharp scissors
- Iron-safe fabric or paper
- Iron

## WHAT YOU DO

**1** First and foremost, read the instructions on the packaging of your transfer paper, since each manufacturer's instructions vary slightly.

**2** Load the transfer paper into your printer, and print out your image in black-and-white or color. Keep in mind that the transfer-paper image will become a mirror image once it has been ironed down. This is especially important if numbers or lettering appear in your artwork.

**3** Cut around the image on the transfer paper with very sharp scissors, to ensure a clean edge.

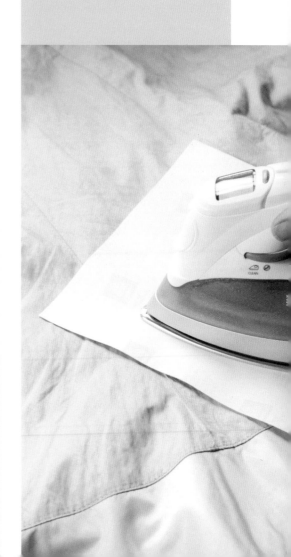

**4** Place your image facedown on your fabric or paper.

**5** Starting at the edges, iron the image onto the fabric or paper. Use even pressure to make sure that the transfer paper doesn't move around while ironing. Run the iron over the image a few times to ensure that it has transferred completely.

**6** Wait a few minutes for the iron-on to cool down. Then gently peel away the paper from your material.

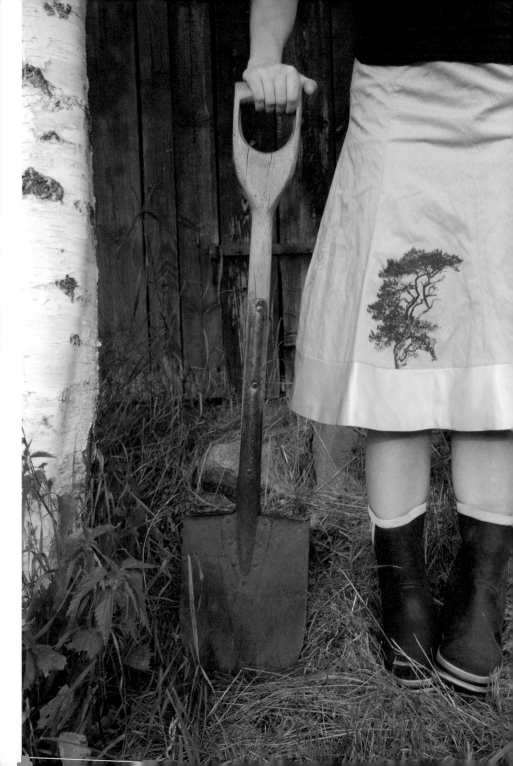

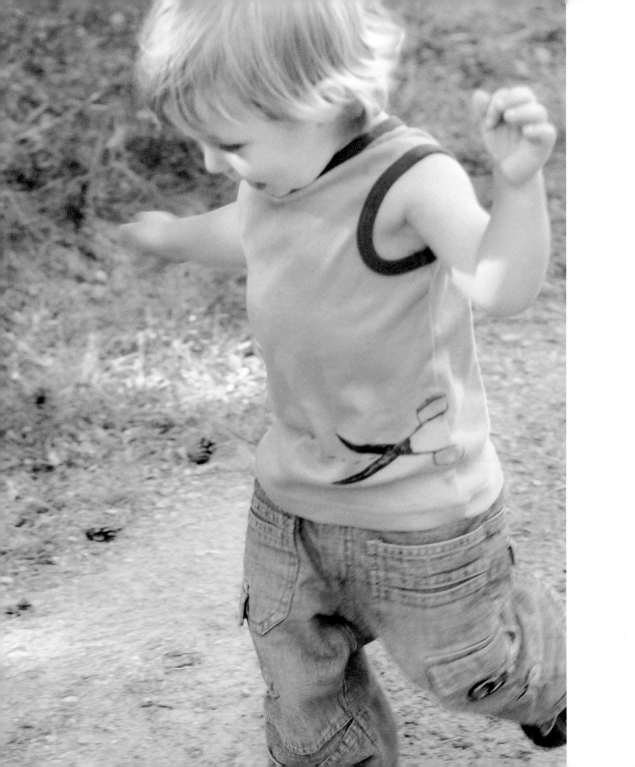

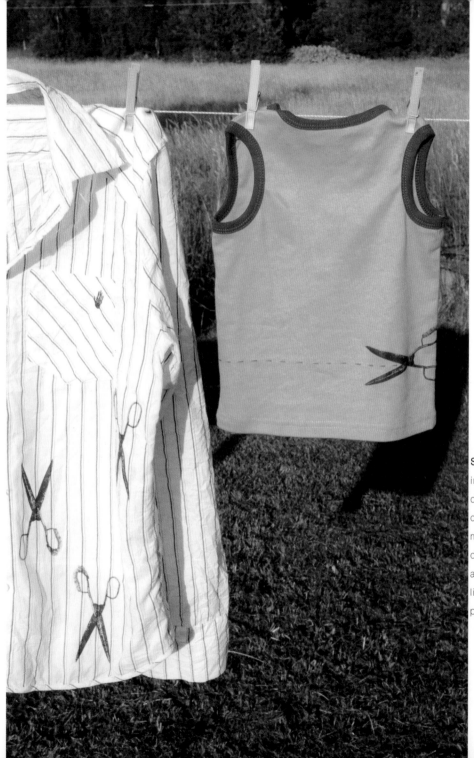

**SHIRTS/** With a little bit of imagination, you can find a lot of different motifs to print on all kinds of shirts for the whole family. Try magazines, textiles, or your own drawings and photos. Here, I used a scissor print and made the dotted line on the toddler's shirt with fabric paint.

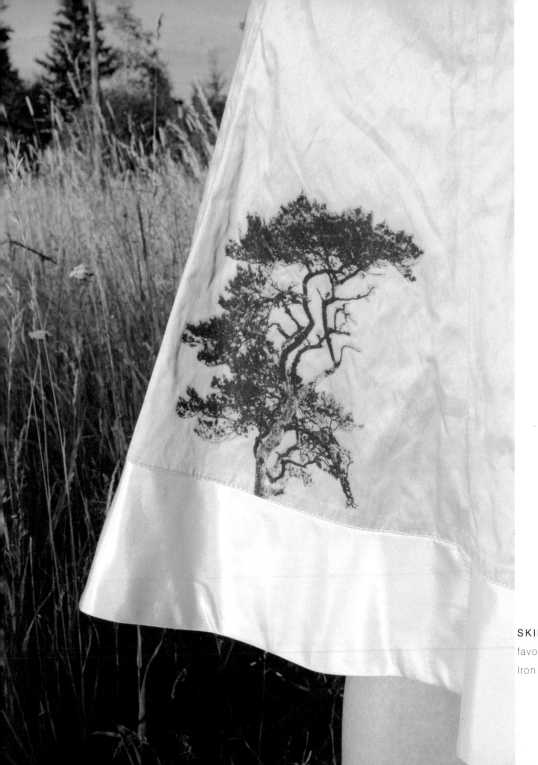

**SKIRTS/** Don't just put your favorite photo in a frame on the wall. Iron it onto your favorite skirt

Inspiration

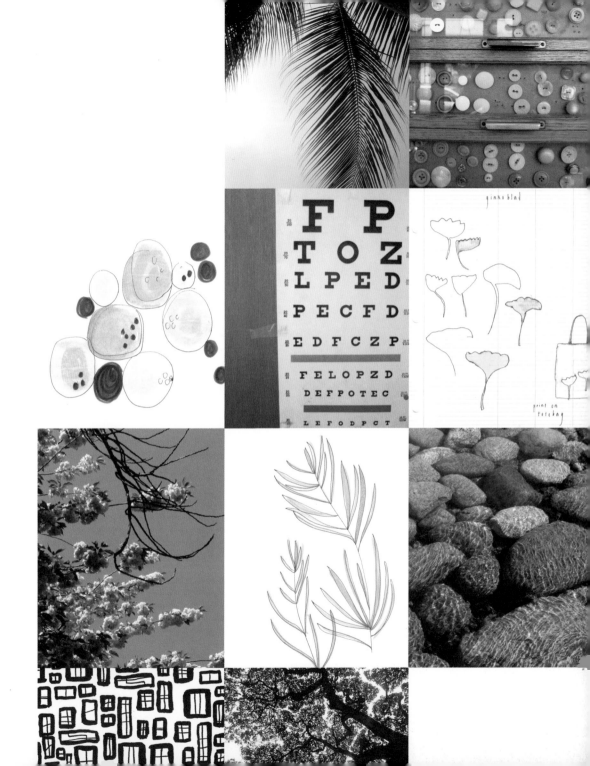

# LEAF PRINTING

When it comes to design, nature really does it best. Why not borrow some of those designs for printing? You can print with fresh leaves as well as pressed and dried plants. It is a very inexpensive process. You'll just need to scavenge in the park or your backyard.

Leaves are, as you know, very delicate; for best results, use lightweight fabrics and smooth papers while printing with them.

# WHAT YOU NEED

- Leaves
- Paint (or ink pad)
- Sponge brush
- Fabric or paper
- Newspaper
- Brayer

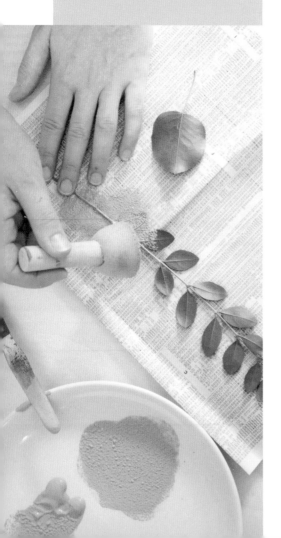

# WHAT YOU DO

**1** Collect leaves in different sizes and shapes.

**2** Lightly brush the underside of a leaf with fabric paint; you can use a sponge brush to do this. The underside shows the veins more clearly and will print better. It is preferable to apply several thin layers of paint rather than adding on a lot of paint all at once.

**3** Place the leaf with the painted side down on your material. Cover the leaf with a piece of newspaper or scrap paper.

**4** Roll your brayer over the paper with one smooth movement. Be careful not to rub too much—rubbing might blur your print.

**5** Carefully lift the leaf from your material.

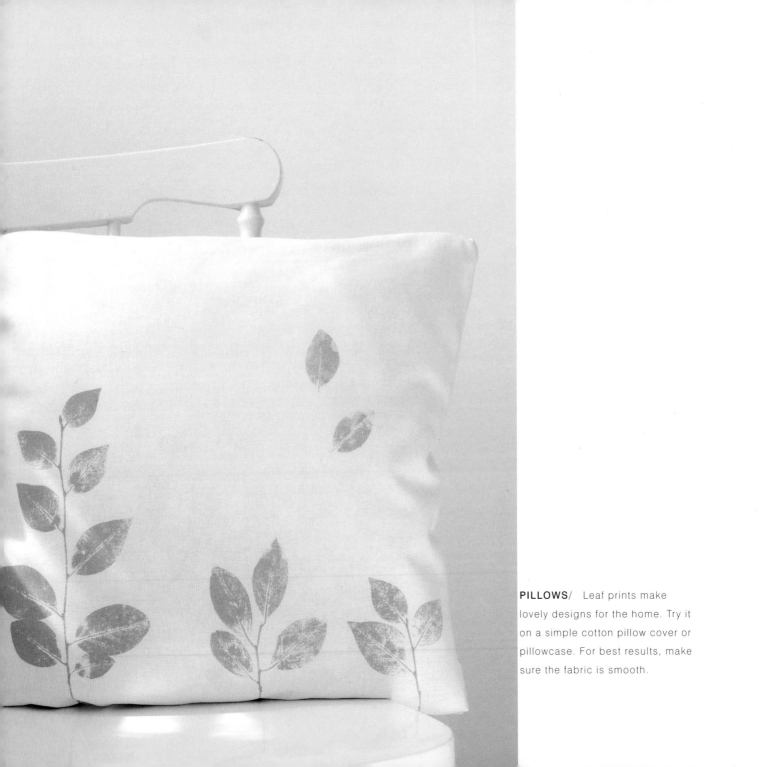

**PILLOWS**/ Leaf prints make lovely designs for the home. Try it on a simple cotton pillow cover or pillowcase. For best results, make sure the fabric is smooth.

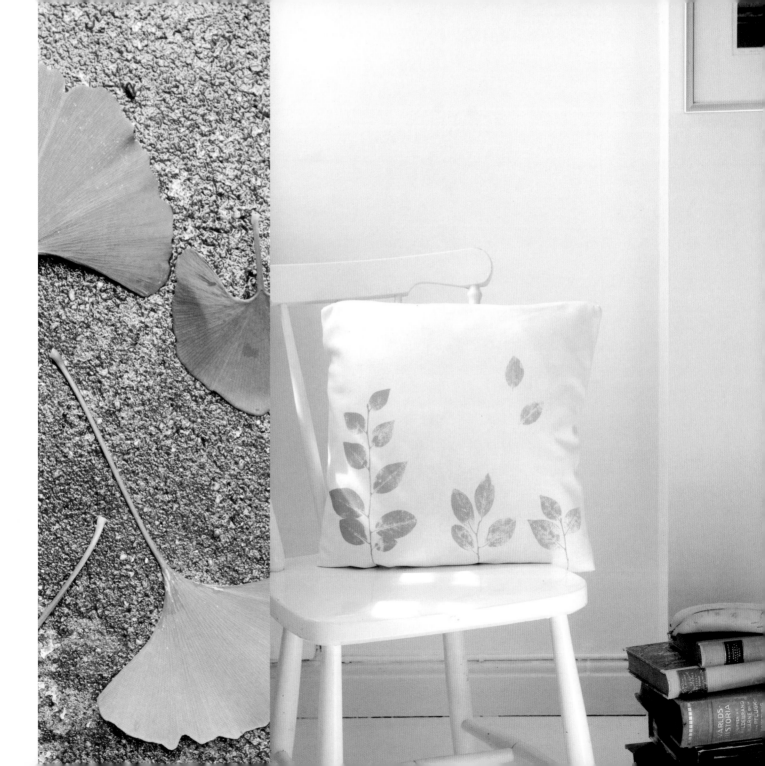

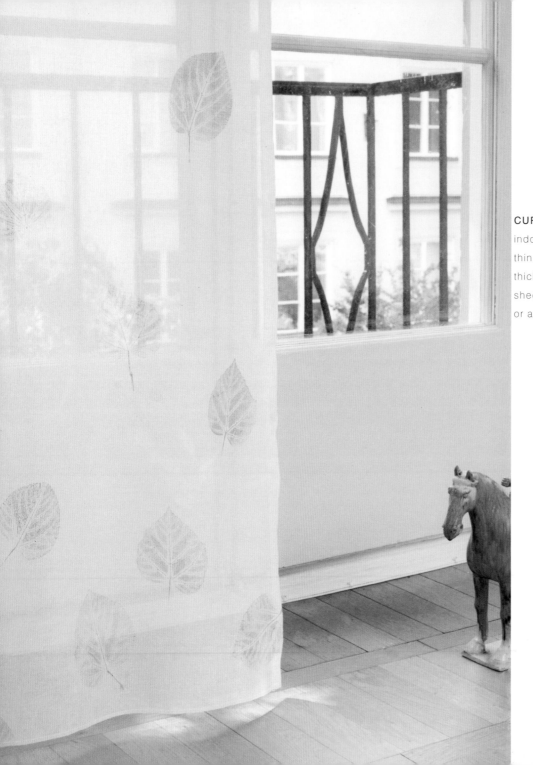

**CURTAINS/** Bring some nature indoors. You can print leaves onto thin, delicate cotton as well as thicker, more sturdy materials. These sheer panels work well as curtains or as room dividers.

Inspiration

# STENCIL PRINTING

Stenciling is one of the oldest surface-printing methods. It's a resist technique, which means that you block the paint or ink from penetrating certain areas of your surface. The beauty of this process is that you can stencil almost anything: clothing, lamp shades, walls, furniture. . . .

It's quite easy to make a stencil. Simply transfer your design onto stiff paper or plastic and cut it out with scissors or an X-Acto knife. Then lay this template on top of the material you are going to stencil on and bring the ink across the template with a hard brush or sponge.

Stenciling works well on both the coarsest and finest of materials. Do take care in creating your stencil design. You should avoid fine lines and delicate details as they are difficult to cut.

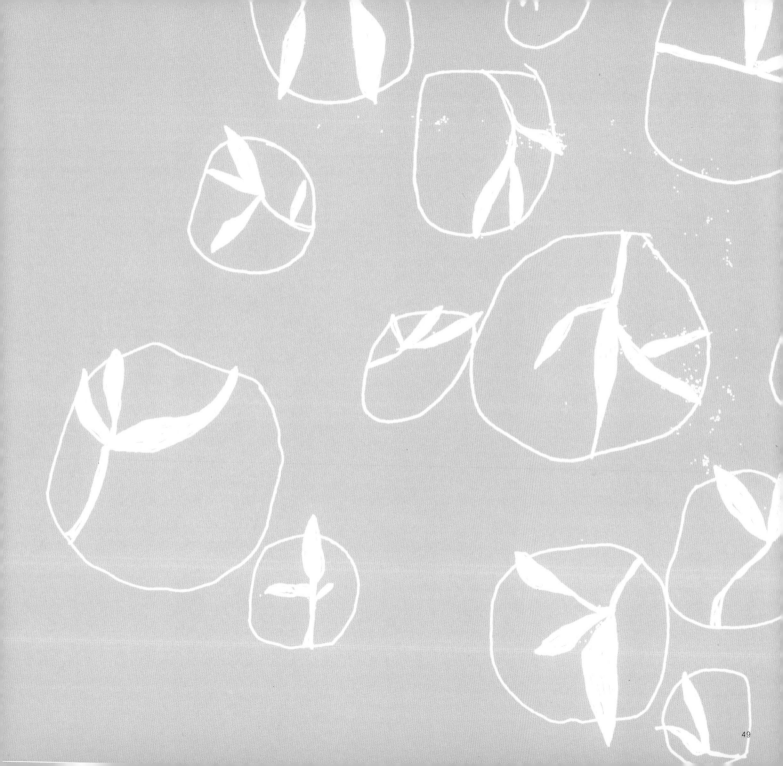

# WHAT YOU NEED

- Permanent marker
- Stiff paper, plastic (acetate), or stencil paper for making the stencils. You can also use self-adhesive clear plastic (contact paper) for making stencils for fabric printing. You'll find it at craft stores and some stationery/paper stores. [See Resources on page 100 for more specific information.]
- Stencil knife (Any sharp pointed knife, or an X-Acto blade, will do.) You can find special stencil knives at craft stores.

- Heavy cardboard or a cutting mat to use as a cutting surface
- Paints or inks appropriate for the surface you are using (fabric or paper)
- Old plate
- Fabric or paper
- Masking tape
- Stencil brush or sponge: Stencil brushes will work best, but any round, stiff-bristle brush will serve the purpose.

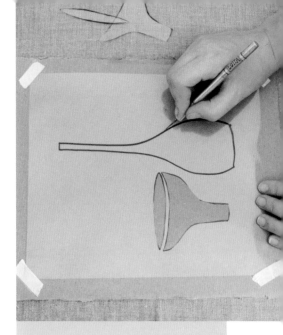

# WHAT YOU DO

**1** Draw your design motif onto the acetate or stencil paper with a permanent marker. Make sure the stencil paper is large enough to leave ample room around the motif; this protects the background material from accidental splashes while printing.

**2** Cut out your design with the knife. You will need to cut a separate stencil for each color used in the design.

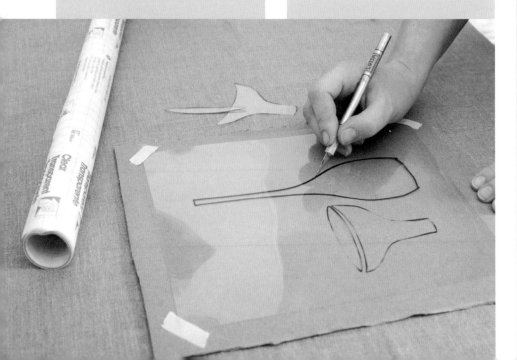

**3** Pour a small amount of paint onto an old plate.

**4** Place your template (stencil) on top of your material. Secure the stencil to the material using masking tape so it will not move during the printing operation. (This is why using self-adhesive plastic as a stencil is so handy: You won't need to secure the stencil with masking tape.)

**5** Dab an even amount of ink through the stencil. Applying several thin layers of ink yields a better result than using too much ink at one time.

**6** If you are printing more than one color: Print all of your designs in one color, and let the print dry before changing stencils. It is easier to use a separate brush or sponge for each color.

## TIP

* When stenciling, it is important that the paint is the right consistency: Paint that is too thick will clog small holes in the template, and paint that is too thin will run under the template.

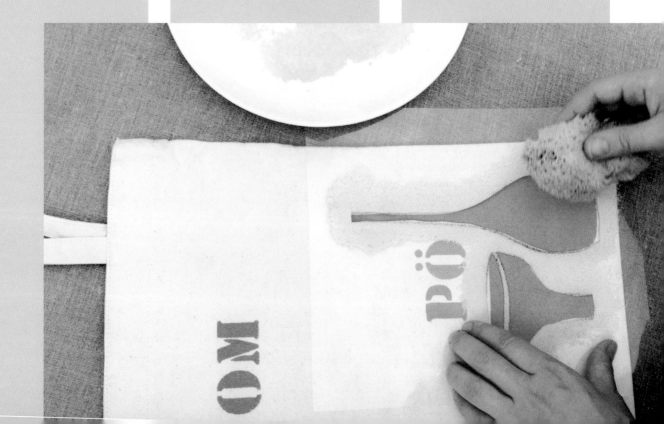

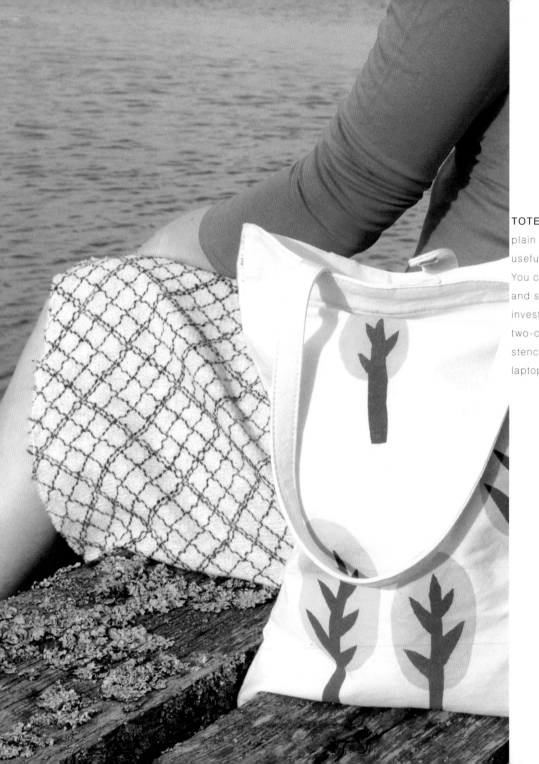

**TOTE BAGS/** I love printing on plain bags. They are economical, useful, and they make great gifts. You can take a very easy approach and simply print in one color, or invest a little more time and plan a two-color design as I did here. Try stenciling your yoga bag, wine tote, laptop case, or eyeglasses case.

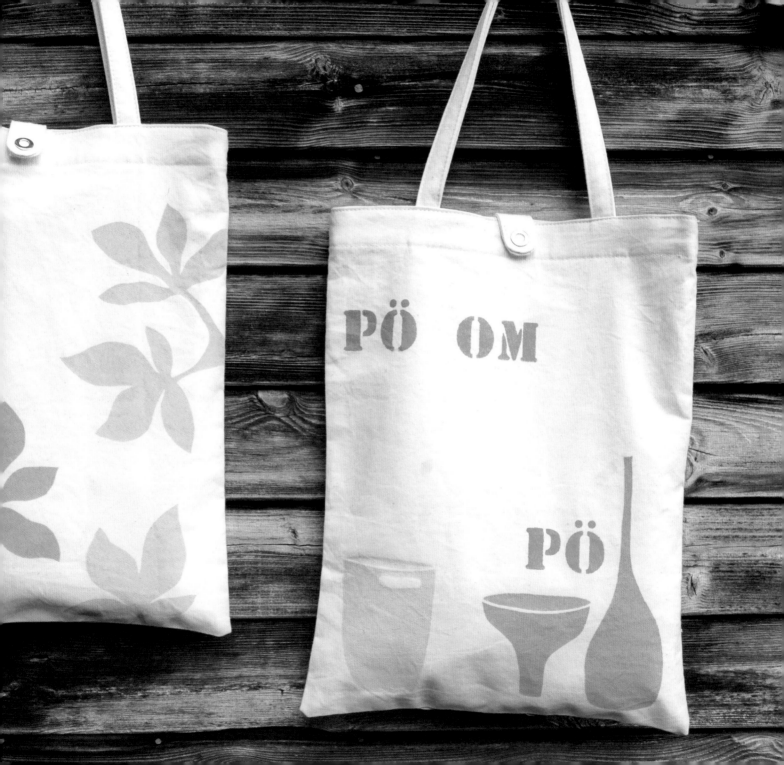

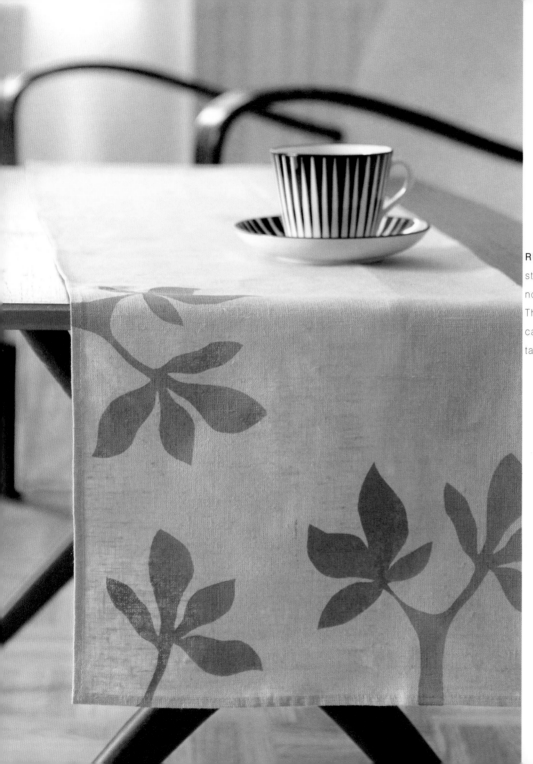

**RUNNERS/** Don't toss your stencils when you're finished! Why not use them for different projects? The stencil you used for a tote bag can easily be used for a beautiful table runner as well.

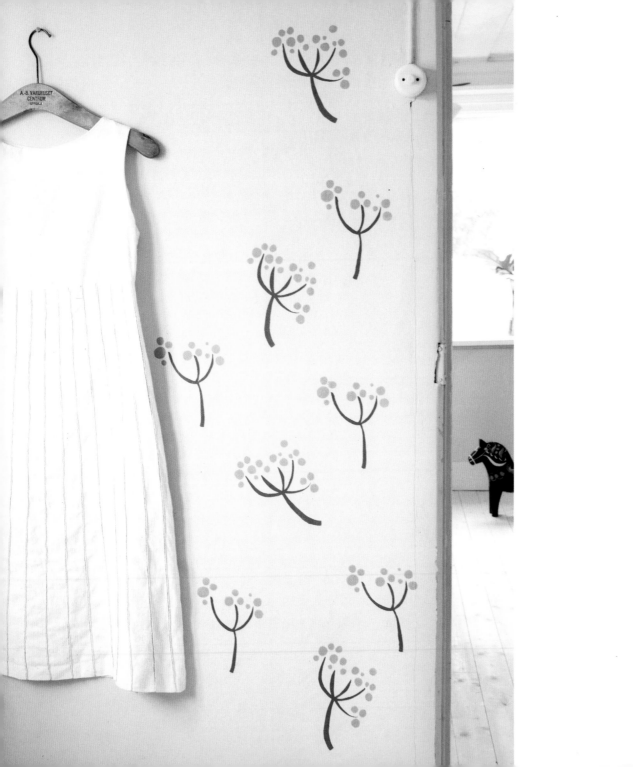

**WALLS/** Decorating walls with stencils is an ancient printing method that goes back in history thousands of years. You'll find stencil work in old churches, cathedrals, and Swedish farmhouses, to name just a few. Stencils work beautifully for both borders and for allover prints. You can either stencil on a grid or stencil in a random layout for a more organic look. On this wall, I scattered the stencil randomly for a charming, playful look.

Before you start stenciling on the wall, you'll want to take some time to properly plan out the design. Mark the placement of the design on the wall with a soft pencil. If you print with more than one color, make sure that each color properly dries before you start printing in additional colors. Using clear contact paper while printing on a wall will prove very helpful, since you can easily apply your ink without having to worry that your stencil will move while printing. Just make sure that the contact paper is not a super sticky one and that it will not adhere permanently to the wall.

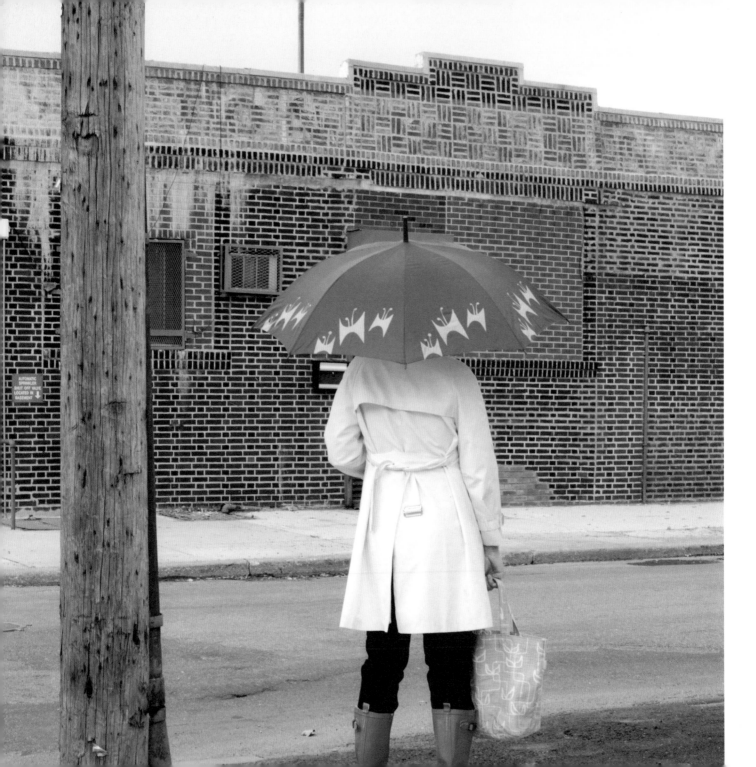

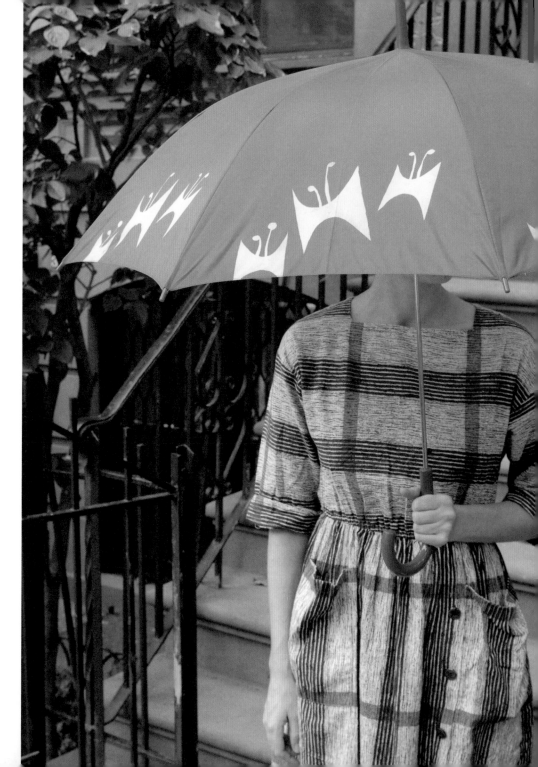

UMBRELLAS/ With a hand-stenciled umbrella, you'll never mix up your umbrella with someone else's again! Before you get started, do a test to make sure the ink you've chosen will adhere permanently to the fabric. I recommend acrylic or enamel ink. Be sure to check with a sales clerk in your art or craft store to make sure that you are using the right kind of ink for a project like this. Once again, using a contact paper stencil will make the whole printing process much easier.

**SCARVES/** Stenciling works on all sorts of fabrics. Personalize a scarf with stencils and fabric paint. Even wool and fleece will work! If you are adventurous, you can try printing on hand-knitted scarves, but it might be a little trickier, since the print surface won't be even.

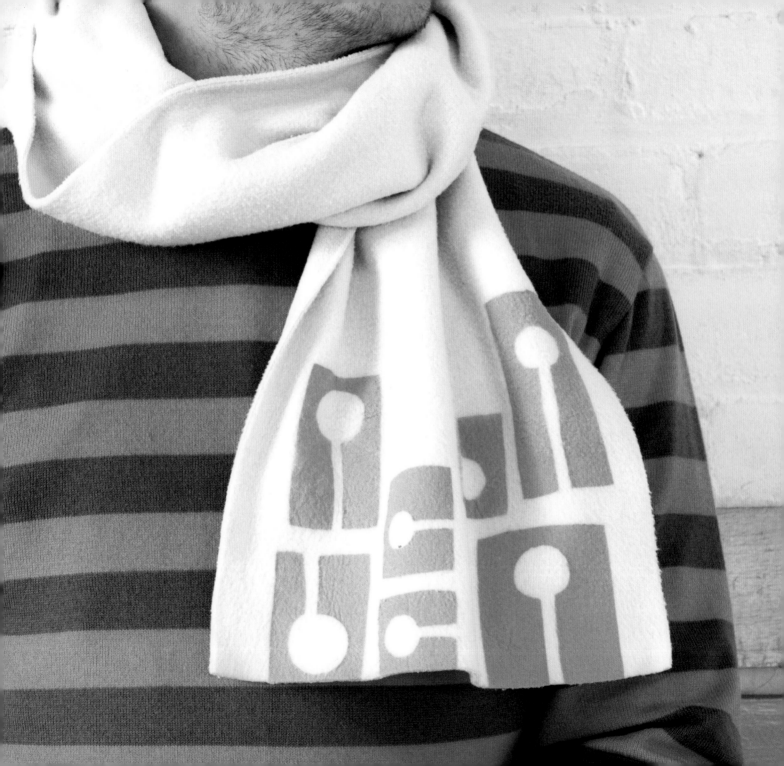

# POTATO PRINTING

You probably remember making potato prints when you were a kid. It's a very simple method. But that's not to say that it's only for small children. A simple potato stamp cut with care and printed tastefully in gorgeous colors can produce a fabulous result. It's a very effective and inexpensive method for printing on fabric and paper.

Making the potato stamp itself is quick and easy. While this method is not ideal for elaborate or delicate designs, you'll find cutting straight lines and simple shapes a snap. Keep in mind that these stamps cannot bear very heavy pressure. You'll achieve much better results if you choose smooth fabric or paper rather than coarse surfaces to print on.

While you're at it, try using turnips, carrots, or a wedge of cabbage—anything that can produce patterns with paint.

## WHAT YOU NEED

– Potatoes (any variety will do, but large baking potatoes are best)
– Paper towels
– Pencil or black marker
– Linoleum or wood-cutting tools (or small kitchen knives)
– Paints, gouache, or fabric paints (The paint should be thick for a bold, sharp print)
– Paintbrushes or sponges
– Ink pad (optional)
– Fabric or paper

## WHAT YOU DO

1  Cut the potato in half.

2  Blot the cut surface with paper towels to absorb as much moisture as possible.

3  Draw your motif onto the potato with a pencil or marker.

4  Using your knife, carve around the outline of your design and cut away the background to a depth of about ¼ inch.

5  Apply inks or paint to your potato stamp with a brush or a sponge, or use an ink pad.

6  Gently press the potato stamp onto your fabric or paper. Press evenly, transferring the image to your material.

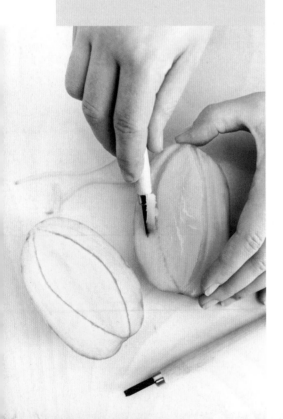

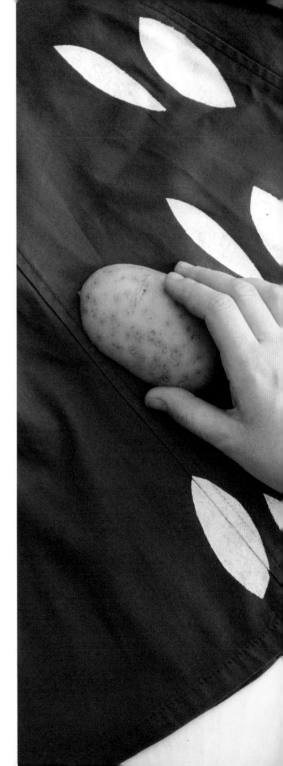

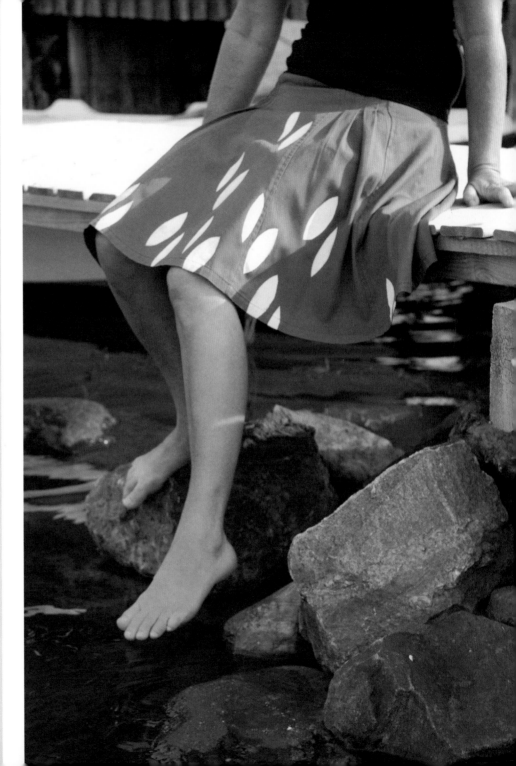

## TIPS

* If details on the potato get clogged with paint, wipe and gently rinse or pat with paper towels before continuing.

* You can easily reuse the same potato to print in different colors. Wash the ink off your potato very carefully with running water, and blot off excess water with a paper towel. Set the potato aside and let it air-dry.

* A potato stamp has a life span of a day or two. If you want to save it for future printing, seal the washed potato stamp in a plastic bag and put it in the fridge. I don't recommend any use beyond two days after cutting the stamp.

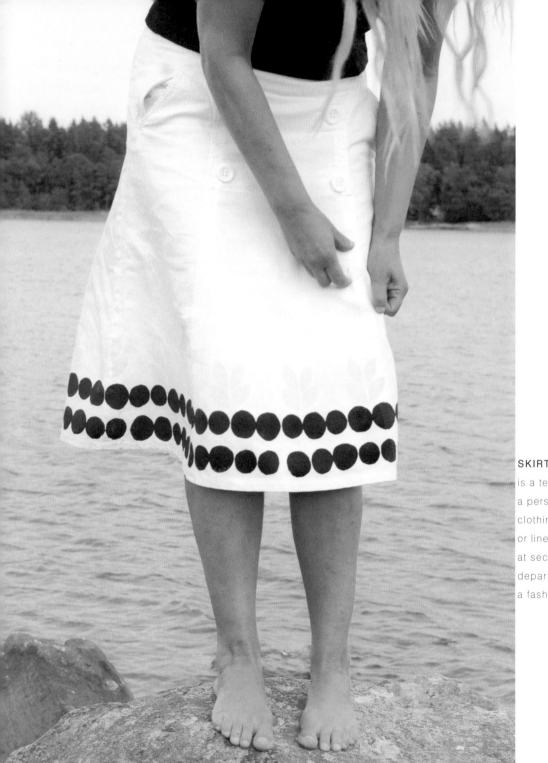

**SKIRTS/** Printing your own skirts is a terrific opportunity to make a personal statement on your clothing! You can find great cotton or linen skirts for very little money at secondhand stores or at bigger department stores, too. You'll create a fashion style that is truly your own.

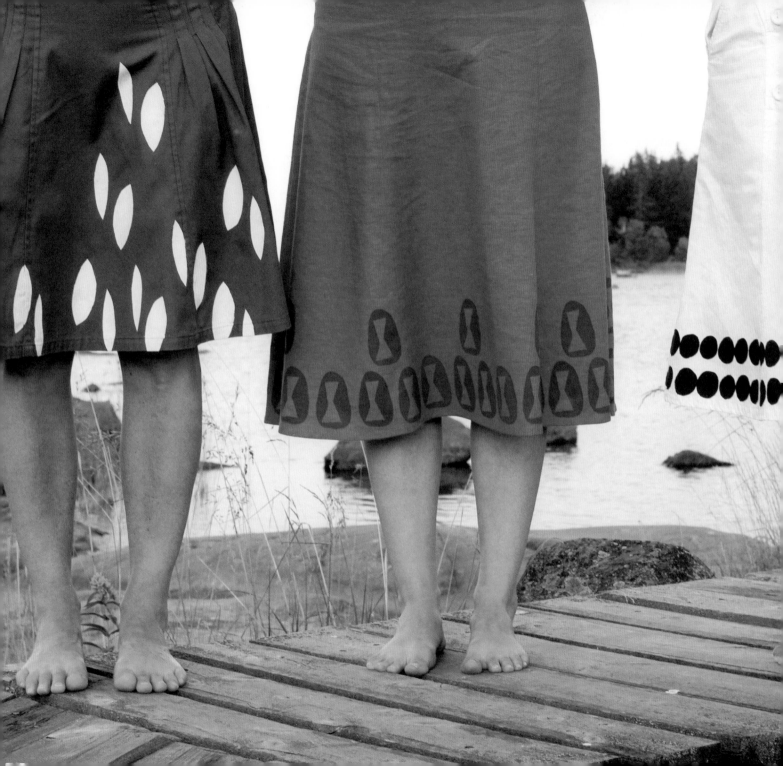

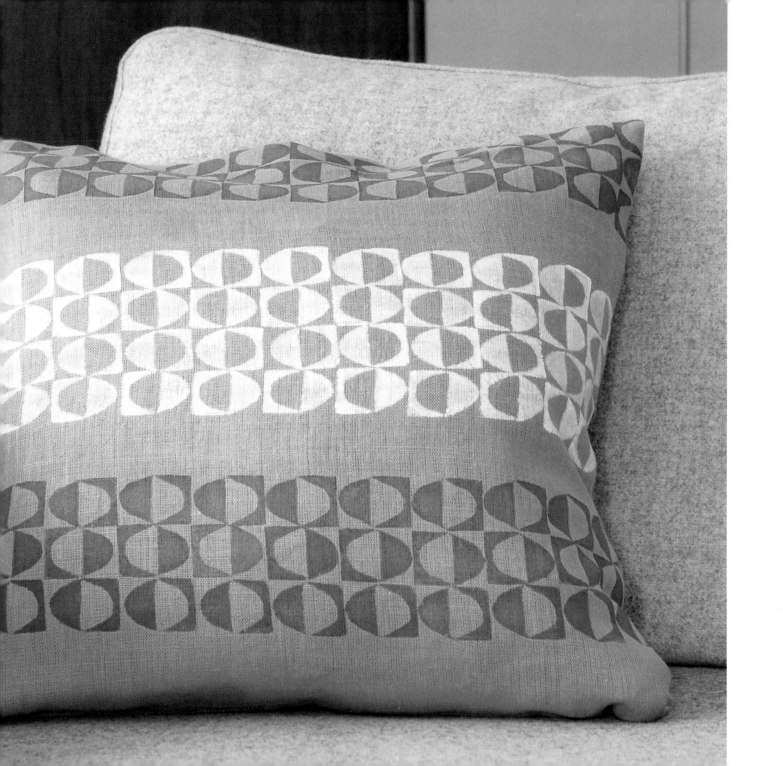

**PILLOWCASES/** Transform plain pillowcases into standout accessories. Even using the simplest design, you can add flair to any room. Try a one-color design or two-color design—the choice is yours! Think about printing on sheets or your duvet cover for a matching set.

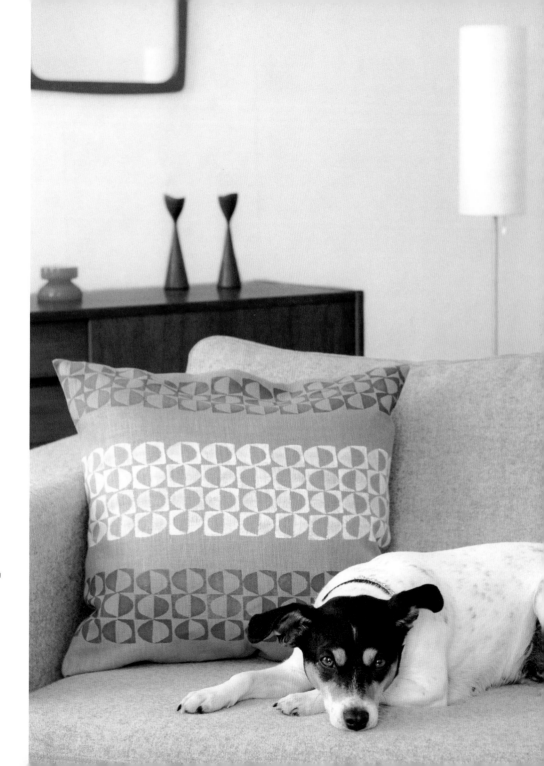

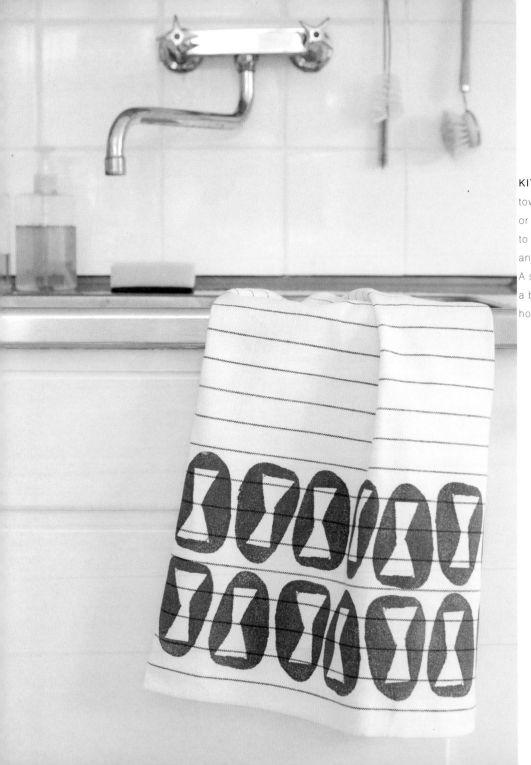

**KITCHEN TOWELS/** Print a set of towels in a jiffy! You can find plain or slightly patterned cotton towels to print on in big department stores and kitchen stores almost anywhere. A set of hand-printed towels makes a brilliant house-warming gift for any hostess.

Inspiration

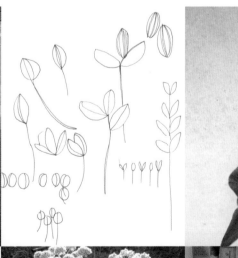

# LINO-BLOCK
# PRINTING

Block printing is a wonderful
technique for creating bold,
graphic designs. You're
essentially creating your own
personalized stamp!

Most block printing uses
linoleum blocks, into which
you carve a design or motif.
Linoleum is made from linseed
oil and either cork or wood
fibers. It's very malleable
for cutting, yet sturdy. You
can buy it in rolls or already
mounted on blocks in almost
any well-stocked arts or
crafts store.

If you're just starting out, you might want to try special blocks, made out of a synthetic rubberlike material, that are much easier to carve than linoleum. These rubber blocks print just as easily and nicely as the linoleum blocks. Brand names include Easy-To-Cut or Soft-Kut. [See Resources on page 100 for more specific information.]

You'll find several different kinds of knives for carving in any arts or crafts store. I suggest a very inexpensive set with five or six differently shaped carving knives with wooden handles. I have always used the inexpensive knives and haven't run into any problems. For the directions on the next page, I recommend at least one U-shaped and one V-shaped tool.

Block printing works well on both paper and fabric. Smooth fabrics such as cotton, fine linen, rayon, and silk are easiest to use. Rough and textured surfaces can look stunning, but it is harder to obtain a very clear print.

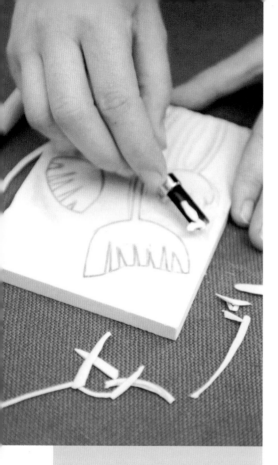

## WHAT YOU NEED

– Carbon paper (optional)
– Pencil
– Linoleum cutters: straight knives, V-shaped tools, and U-shaped gouges.
– Piece of mounted linoleum or rubber block
– Paint or ink
– Paper or fabric

– Soft rubber brayers, small paint rollers, or paintbrushes
– An old cookie sheet, a wax-coated paper plate, or a piece of Plexiglas (to roll the ink or paint out on)

## WHAT YOU DO

1  First, decide what sort of design you'd like to create. Bold graphic designs work best. You can draw your design out on paper first and then transfer the image to the block using carbon paper, or you can use a pencil to draw your design directly onto your block. Keep in mind that the areas you carve away will be the negative space. The areas left will hold the ink.

2  Using the linoleum cutter, carefully carve the design into your block. Always cut AWAY from yourself. And make sure you are using sharp tools—dull knives are harder to use and are therefore more likely to cause injury.

3  Once you're happy with your carving, squeeze out a small dollop of paint or ink onto a piece of Plexiglas or an old baking sheet. Roll the brayer over the ink to spread it out. Make sure the brayer is thoroughly covered with an even layer of ink before rolling it over the block.

4  Roll brayer over the block, applying several thin layers to coat the raised areas.

5  Once you have even coverage, place the block facedown on your fabric or paper. You'll need to apply even pressure to get a good print. If the print is on the small side, you can use your hand to press down on the block. If the print is larger, use a rolling pin to gently press the block evenly onto your printing surface. Take care not to let the block move while applying pressure. You can also try lightly rubbing the surface with the back of a spoon.

6  It is always a good idea to do some test prints before you start making your final prints. This way you'll figure out which method works best for you.

## TIPS

* To make for easier cutting, warm the linoleum block on a hot plate or in the oven before carving into it. Be sure to use low heat. You do not want to start a fire! There's no need to warm the rubber blocks; they're already soft.

* If you're confused about positive (the raised part of the finished stamp) and negative (the area you will carve away) space, mark your design clearly after you transfer the outline. For example, scribble over all the negative space in red and all the positive space in green. Use this as a guide while you carve.

* If the inks you use are water-soluble, you can easily just wash off your blocks under running water. The blocks are water-resistant. Use paper towels or cloth towels to dab off the water, and let the block air-dry completely before using it again. If you use any other type of ink or paint, please follow the instructions on the packaging to clean the block.

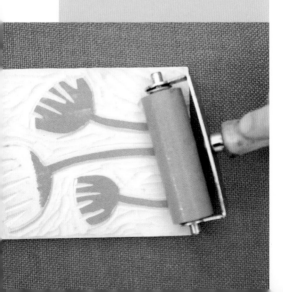

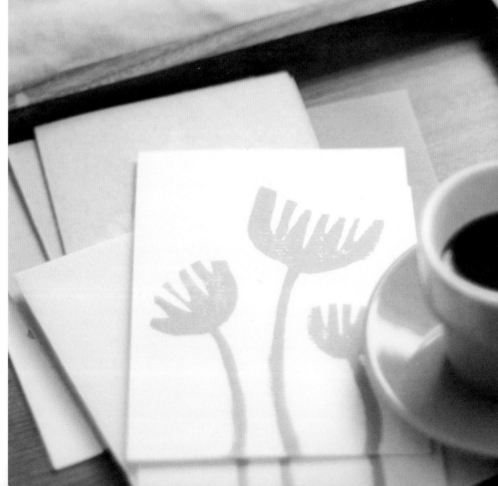

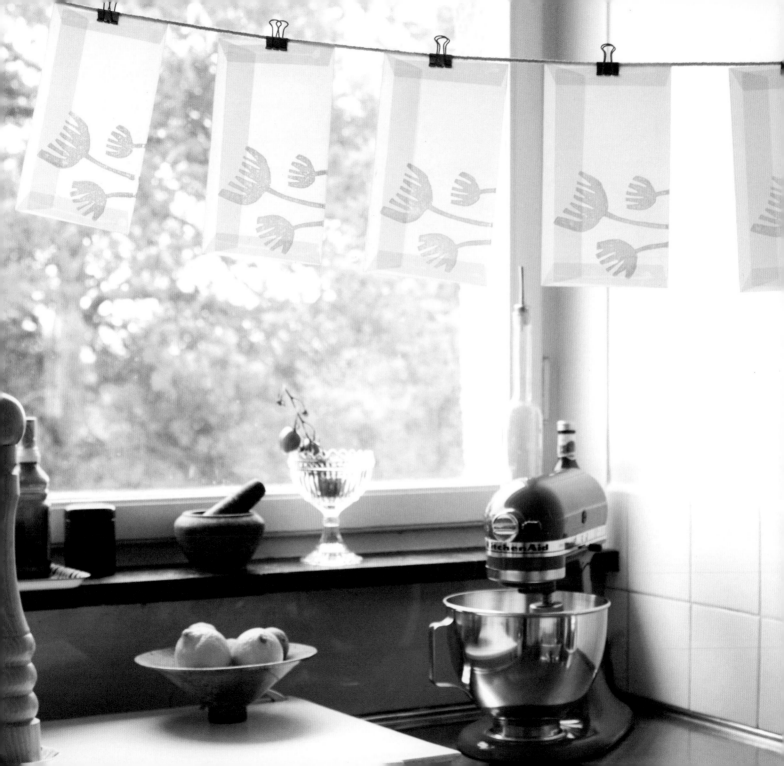

**CARDS/** Add charm to your correspondence with stationery that you've designed and printed yourself. Printing an edition of cards and envelopes is not that difficult at all. Create interchangeable corresponding motifs—one for the envelopes and one for the cards. Mix and match!

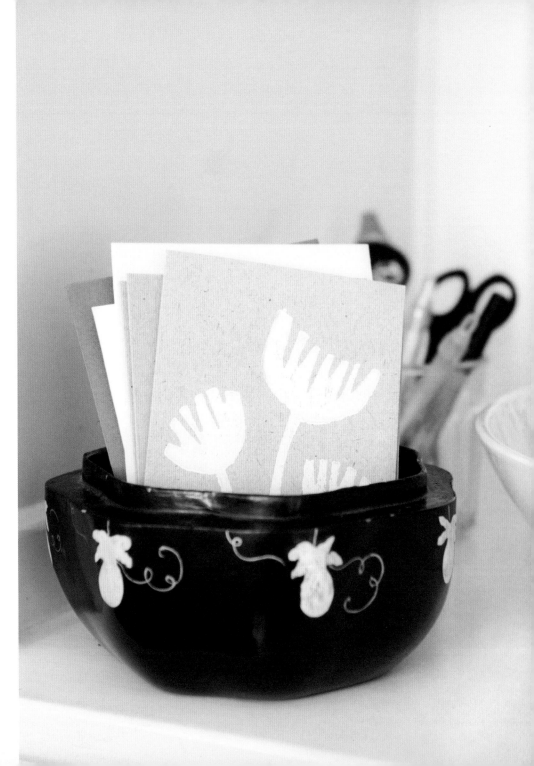

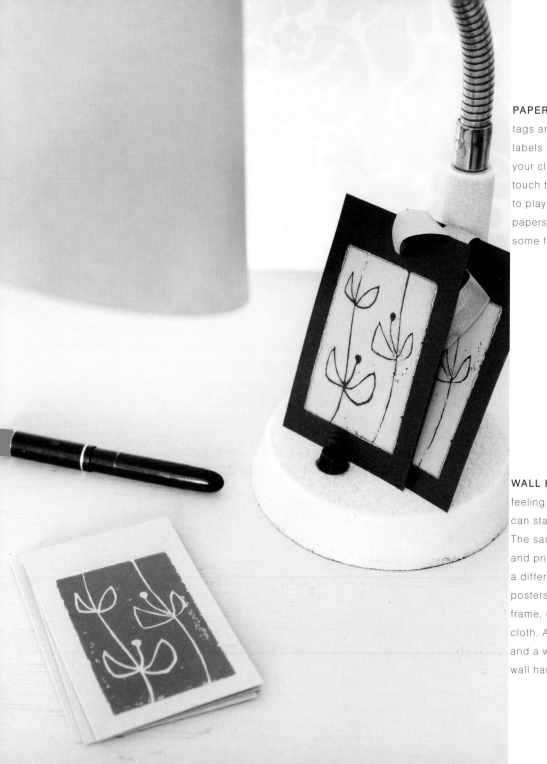

**PAPER TAGS/** Hand-printed paper tags are so useful on jam jars, as labels for all the different boxes in your closet, or to add a personal touch to a present. I encourage you to play around with different colored papers and inks. You'll come up with some fabulous combinations.

**WALL HANGINGS/** If you are feeling a tad more ambitious, you can start printing larger pieces. The same easy process in carving and printing applies; it is just on a different scale. You can print posters and nice limited editions to frame, or you can print scrolls on cloth. Add color to your living room, and a whole lot of personality, with wall hangings in paper or fabric.

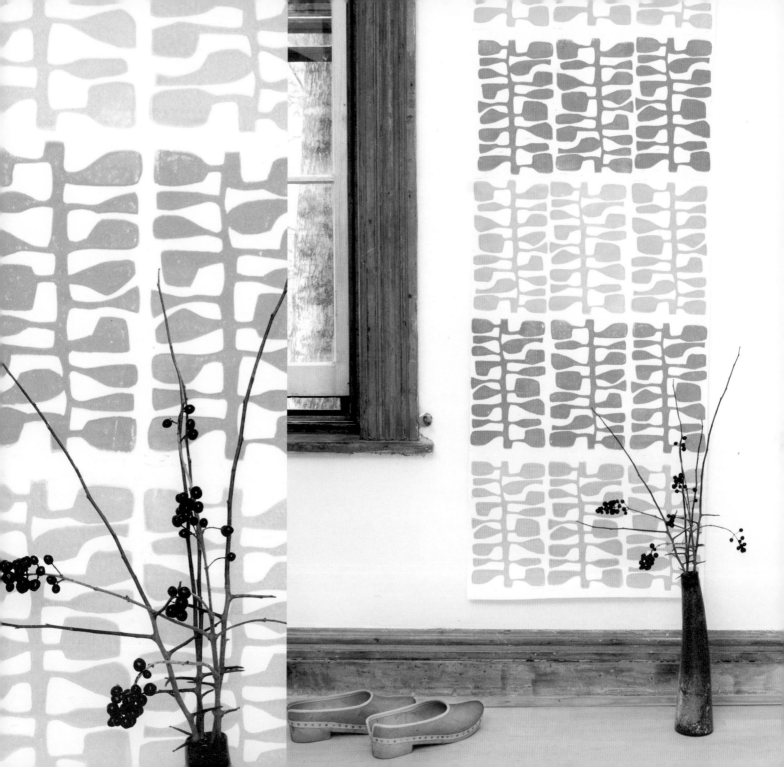

# SCREEN PRINTING

If you're looking to create very detailed, very consistent results, screen printing is for you. Like stenciling, screen printing is a resist technique; you block all the parts you don't want printed. Prepping your screen does take a fair amount of time, but once you have your screen all set up, you can make as many prints as you want, one right after another. It's mass production heaven!

Since screen printing has become very popular in the last few years, you will find that most well-stocked art stores carry screen-printing supplies. You will find screens in different sizes and with different mesh counts. Think of the mesh count as you would thread count for your sheets. A higher mesh count produces finer details and a higher quality print.

You can make your own screens or buy them pre-stretched and ready to go. It's certainly easier to buy them. Nevertheless, if you're handy, use wood stretcher bars for the frame and then stretch screen-printing fabric over the frame. Use a heavy-duty staple gun to attach the fabric, making sure it is secured very, very tightly around the wood frame. [See Resources on page 100 for more specific information.]

When it comes to prepping your screen for printing, there are several different techniques. In this chapter, I will cover three basic ways to prepare the screen: contact paper, screen filler, and photo emulsion. You will find step-by-step directions for all three techniques. The screen-filler method is the most widely used, so I've included photos to demonstrate this technique.

I have also included some photos of items you can print with the contact-paper and photo-emulsion methods. My hope is that you will find them inspiring and that they will entice you to want to learn more. If you would like to take screen printing a step further, please look in the Resources section, page 100, for information about how and where you can learn more.

No matter which method you use to apply your design to a screen, the printing steps are the same. Once you've prepared your screen, turn to page 90 for printing directions.

## CONTACT-PAPER METHOD

This is the simplest and fastest method, which makes it great for beginners. Please note, this technique works well for simple designs. But fine lines and small details are trickier—both to cut and to print—using this method.

## WHAT YOU NEED

- Scissors or X-Acto knife
- Contact paper
- Permanent marker
- A cutting surface for use with a knife, like heavy cardboard or a cutting mat
- Frame (pre-stretched with a screen and ready to go)

## WHAT YOU DO

**1** Cut out a piece of contact paper a tad smaller than your frame.

**2** Place contact paper facedown on your working surface (the backing will be facing up).

**3** With the permanent marker, draw your design on the back of the contact paper. Make sure to leave plenty of room around the motif— aim for at least five inches.

**4** Use scissors or a knife to cut out all the parts of the motif that you want to be printed. (Keep in mind: the remaining contact paper will block the ink from printing). Make sure to cut through both layers— the contact paper and the paper backing. If you plan to do a multicolor print, you will need to cut a separate contact-paper stencil for each color used in the design.

**5** Remove the paper backing from the contact paper and stick the adhesive side onto the flat side of your screen.

**6** Please see page 90 for printing directions.

## SCREEN-FILLER METHOD

This is another simple method to prepare your screen. You will paint screen-filler fluid directly onto the screen, blocking out those areas you do not want to print.

## WHAT YOU NEED

- Soft pencil
- Frame (pre-stretched with a screen and ready to go)
- Screen-filler liquid
- Brushes

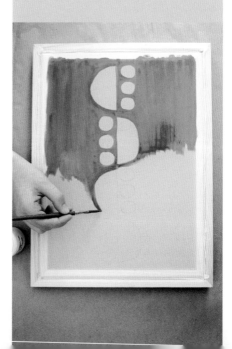

## WHAT YOU DO

**1** Draw your design directly onto the screen with a soft pencil. Make sure to draw on the top side of the screen (the recessed side).

**2** Stir the screen filler and then use a brush to paint the screen-filler fluid directly onto your screen, on the recessed side. Keep in mind that the screen filler should be painted only in those areas of your design that will not be printed. The areas without the screen filler will be the areas the ink penetrates.

**3** Apply several thin layers of screen filler. Working with several layers will assure a more even coat and the filler will last longer. Be sure to check both sides of the screen to make sure that no excess screen filler has pooled in any areas; if it has, simply even it out with your brush.

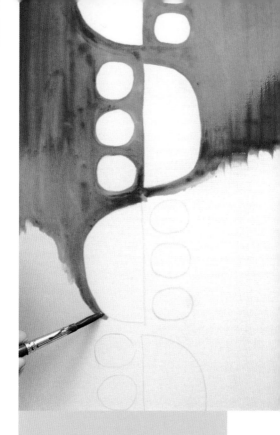

**4** Hold the screen up to a light to make sure you haven't missed any areas or left holes in your screen.

**5** Lay the screen flat on a level surface, like a table or the floor, to dry. Make sure that the screen filler dries completely before starting to print. It's best to leave it to dry overnight.

**6** Please see page 90 for printing directions.

# PHOTO-EMULSION METHOD

You can achieve the highest level of detail with this method. It's terrific for printing your own drawings or photos.

## WHAT YOU NEED

– Photo-emulsion kit that includes
photo emulsion, sensitizer, and
emulsion remover
– Frame (pre-stretched with a
screen and ready to go. Make sure
that it is a polyester screen fabric,
and not nylon or silk.)
– Squeegee or a very stiff piece of
cardboard (no wider than the width
of your screen)
– Acetate paper
– India ink (optional)
– Black paper (at least as large as
your screen)
– A light source (with a clear,
incandescent 150-watt bulb)
that you can position above your
workspace
– A film positive (this is your
artwork)
– A clear, flat piece of glass or
Plexiglas (no larger than your
screen)

## WHAT YOU DO

### PREPARE YOUR SCREEN

1  Mix the emulsion, following the
instructions on both of the bottles.

2  To coat your screen, pour a little
bit of the solution on one end of the
screen, and use your squeegee or
cardboard to spread a thin coat of
the emulsion evenly over it. Repeat
this process on the other side of
your screen. Return any excess
emulsion back to the container.
If you can, try to do this step in an
area that is dimly lit because the
emulsion you are working with is
light-sensitive.

3  Set the screen aside to dry: lay
it horizontally in an area that has
absolutely NO light or heat. Once
the screen is dry, keep it in the dark
until you are ready to expose it.

### PREPARE YOUR ARTWORK

1  There are a few ways to prepare
your artwork (the film positive) for
printing. You can draw your design
directly onto acetate with India
ink. You can also photocopy or print
a black-on-white motif onto acetate.
Whichever method you choose,
make sure that the artwork is
completely opaque. No light should
be able to penetrate.

## EXPOSE YOUR SCREEN

**1** Make sure that you have set up properly before you bring out your frame; have all your supplies close by and ready to use.

**2** Place the frame, flat side up, on top of the black paper, with the light centered 12 inches above the frame (but don't turn the light on yet!).

**3** Place your artwork on the screen, and lay the sheet of glass on top of it. Be sure that you position the artwork correctly, so it will print the way you intend—especially true if you use lettering or numbers in your design.

**4** Now you are ready to expose your screen. Turn on the light, being sure that the light hits all parts of the screen.

**5** The exposure time depends on your screen size. Assuming you are using a 150-watt bulb, follow this time chart:

| screen size | exposure time |
| --- | --- |
| 8 x 10" | 45 minutes |
| 12 x 18" | 75 minutes |
| 18 x 20" | 90 minutes |

**6** After you've exposed your screen for the appropriate amount of time, apply a forceful spray of cool water to both sides of the screen for a couple of minutes. DO NOT use hot water when doing this. As you spray, you will see some areas of the photo emulsion wash away: this is your design. You can also carefully rub your hands over the screen to help remove the excess screen fluid.

**7** After a few minutes of washing, you should be able to see your design on the screen. It should come out clean and crisp—very close to your original artwork.

**8** Dry the screen off by gently blotting with a towel. You can also use a hair dryer on the low setting. Or, if you're the patient type, lay the screen flat to air-dry—this is probably the safest method.

**9** After you've dried the screen, hold it up to light to check for any small spots or holes. You can cover these with a little emulsion, using a small brush.

**10** See page 90 for printing directions.

If you find that there are areas in your design where the emulsion won't wash away, it might mean:

• That your original artwork was not opaque enough and light got through your design (and therefore exposed your screen to light where it was not supposed to be).

• That you did not expose the screen to light long enough.

• That the screen was moved during exposure.

• That you did not apply enough emulsion to the screen.

In all of these cases, it means that you have to start over again: Clean your screen, dry it off, and expose it again, following the same steps to expose your screen.

# PRINTING
# METHOD

No matter which screen-printing method you used to apply your design, you will use the same steps for printing. It's true that it takes a bit of practice and dexterity to get the hang of screen printing, but once you get going, you'll be hooked.

To produce a series of successful prints, you'll need to make sure the amount of padding on your work surface is even, the angle and pressure of the squeegee is consistent, the ink is the same consistency for each print, and the paper or fabric is all of the same quality. It will likely take a bit of trial and error to get the effect you're looking for.

Please remember, sometimes the best results occur while making happy mistakes. So keep experimenting and trying different methods and soon you will find your own printing style and technique. Don't give up!

If you are planning to do a print with multiple colors, you'll need to prepare a separate screen for each color. First, print all the prints you need in the first color and let them dry. After that, print your second color on top of the material you printed with the first color, and so on.

## WHAT YOU NEED

- Frame (pre-stretched with a
screen and ready to go)
- Fabric or paper
- Water-resistant masking tape
- Squeegee or plastic spatula
- Inks or paints
- Paper towels or rags
- Old newspaper
- Hinges
- C-clamps

## WHAT YOU DO

**GETTING READY**

Make sure that you are properly
prepared before you start printing:
Have your materials ready, inks
mixed, and paper towels on hand.
Lay out some newspaper to rest
your squeegee on between print
runs, and clear out an area where
your printed items can dry.

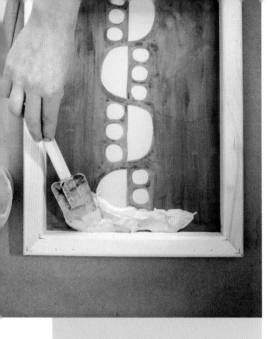

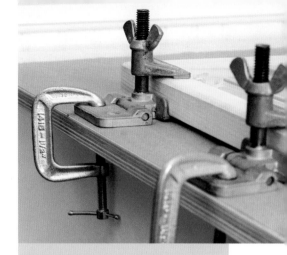

## PRINTING

**1** Place your fabric or paper under the screen in the position you want. I usually mark the placement of my material with masking tape, so I know exactly where to place it on the work surface each time. (This, of course, requires the paper or fabric to be the same size each time.)

**2** Drop your screen down onto the paper or fabric.

**3** Place your squeegee or spatula at the top of the screen. Spread the ink or paint across the screen along your squeegee blade. Keep your squeegee at a 45-degree angle and pull it toward you in one smooth and firm movement.

You can hold the squeegee with one hand for smaller prints. If you are creating a bigger print, use both hands to hold the squeegee.

**4** Lift the screen from your material. Take a good look at the print: does it need more ink? Could you have used more or less pressure while printing? These are good questions to ask yourself, after the first test print and throughout the process.

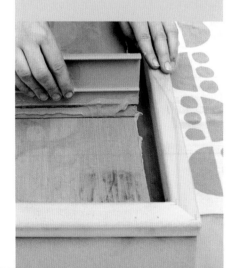

**5** Repeat these steps making as many prints as you like.

You can secure your screen to the work surface as shown in the photo above. Attach the two hinges to your frame and secure them to your worktable by clamping a C-clamp onto each hinge.

## CLEANING UP

As soon as you are done printing,
you'll need to clean your screen
right away to avoid the ink drying
onto it and clogging up the
design, or even ruining the screen.
If you are using water-based inks,
you can easily wash your screen
by simply rinsing it well with water;
make sure to rinse the screen on
both sides. If you use any other
inks or paints, please follow the
cleaning recommendations on the
package.

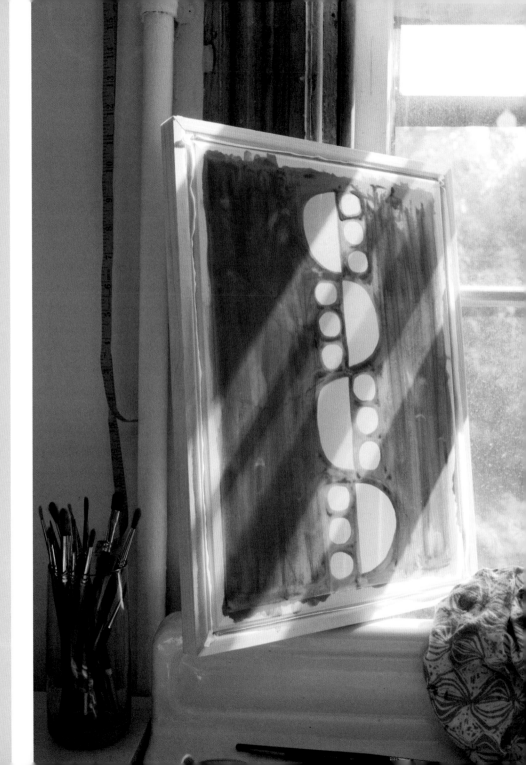

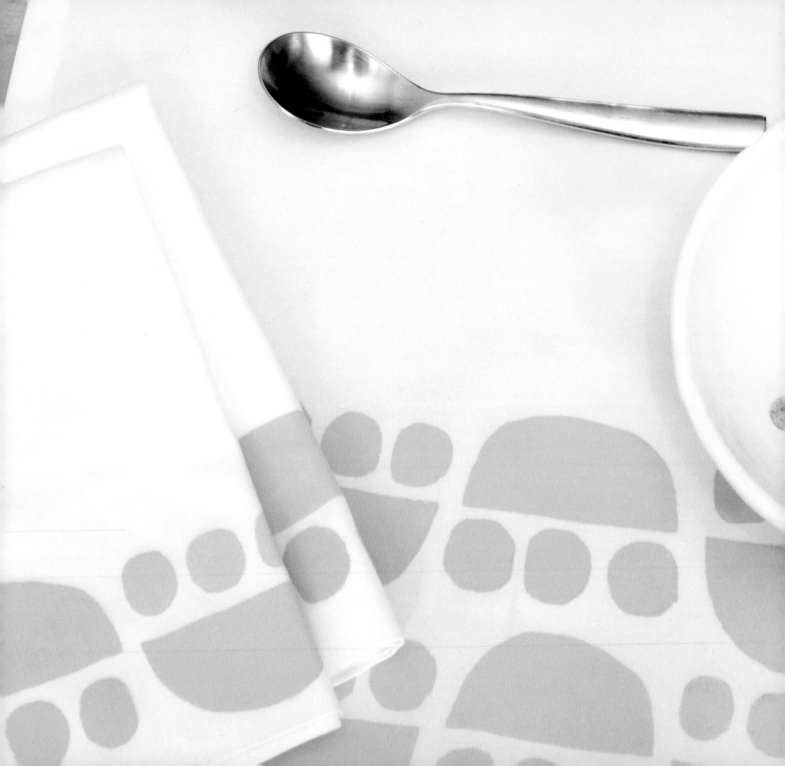

**TABLE LINENS/** For a fresh look on the table, why not print some of your own designs on table runners and napkins? You can print along the hem for a nice border design or place your designs more randomly all over the linens.

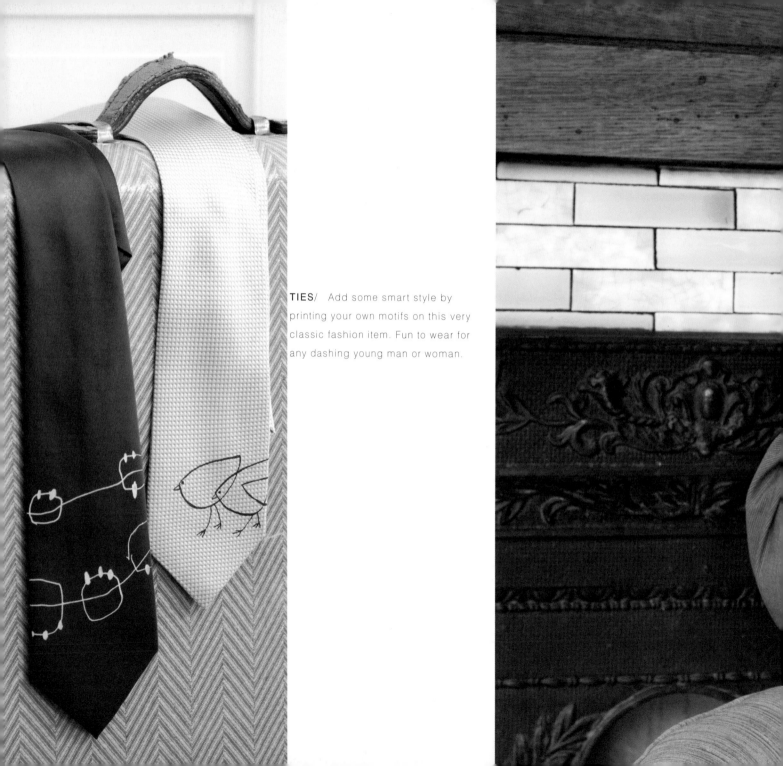

**TIES/** Add some smart style by printing your own motifs on this very classic fashion item. Fun to wear for any dashing young man or woman.

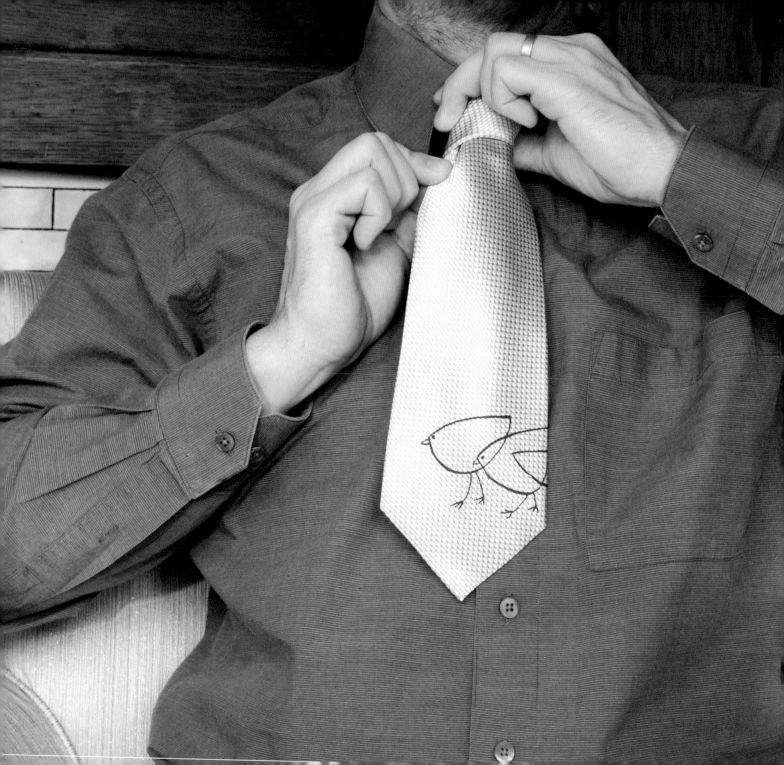

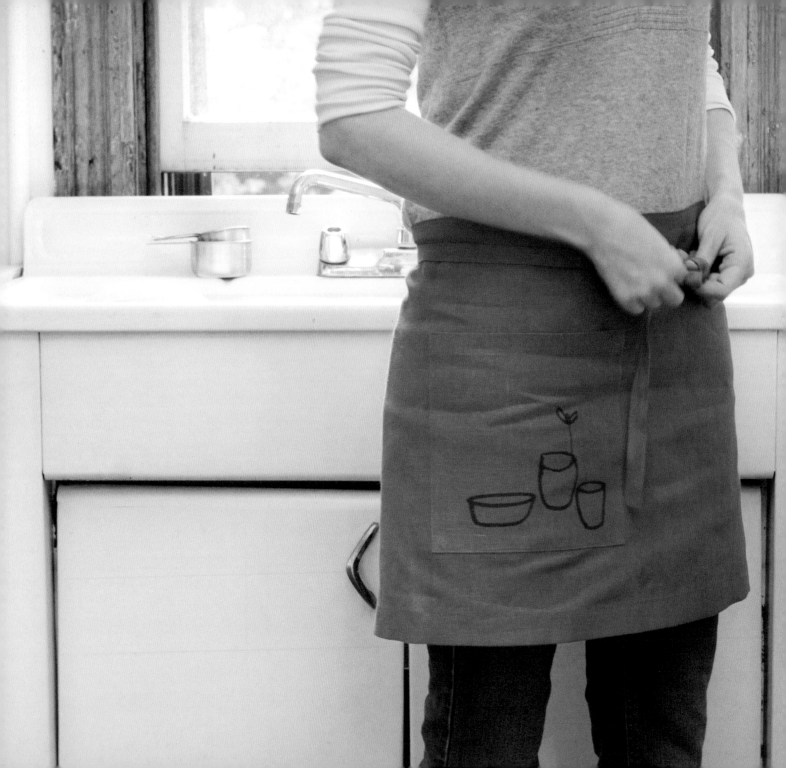

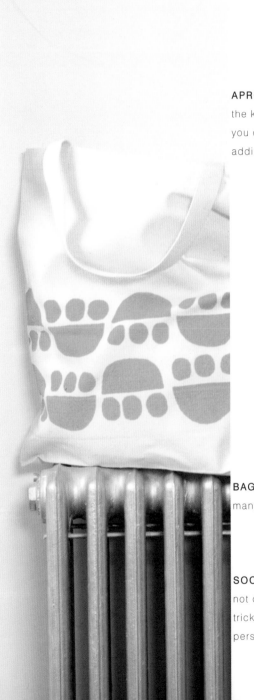

**APRONS/** Add a bit of chic to the kitchen. With screen printing you can enhance any plain apron, adding whimsy to the practical.

**BAGS/** One can never have too many bags!

**SOCKS/** Printing on things that are not completely flat might be a little tricky, but with some patience and perseverance, you can do it!

# RESOURCES

## SUPPLIES:

www.dickblick.com

www.pearlpaint.com

These two art and craft supply stores carry EVERYTHING you could possibly want for all your surface-printing needs (except for the leaves for leaf printing). You can buy your ink pads for stamping, acetate for stencils, printing blocks, carving tools, some simple screen-printing supplies, and much, much more.

www.staples.com

You can find the iron-on transfer paper here, as well as some basic, inexpensive office stationery to print on.

www.dharmatrading.com

On this Web site, you can find all the supplies and tools you might need to print or dye fabrics. They have screen-printing kits, clamps (for screening), blanks to print on (scarves, clothing, and textiles in a variety of print-friendly fabrics), iron-on transfer papers, and also many books.

www.victoryfactory.com

A great site for screen-printing supplies and equipment. You can find materials for making your own screens, as well as already prepared screens.

www.bestblanks.com

Here you can find heat-transfer paper and all kinds of blanks to print on.

www.americanapparel.net

Blank T-shirts to print on . . . for him, her, baby, and even the dog!

www.paper-source.com

This company carries a wide array of blank stationery (cards and envelopes) that are very good to print on. There are many different beautiful colors to choose from.

www.rubberstampinglinks.com

You will find links to an exhaustive list of rubber-stamping Web sites here. You'll be able to find stamps and ink pads, techniques and tips, as well as where to get your own custom stamps made.

www.hankodesigns.com

One of my favorite sites for pretty, Asian-inspired rubber stamps. They also carry nice papers that are great to stamp on.

www.mjtrim.com

Here you can find ribbon to print on. Remember to pick natural materials, such as linen, cotton, or silk ribbon—they print better.

## TEXTILES:

Visit some of these fabulous textile designers:

www.maisongeorgette.com

www.deadlysquire.com

www.hableconstruction.com

www.hauhauz.com

## TO LEARN MORE:

www.selvedge.org

Selvedge is a magazine, a Web site, a book store, and a GREAT resource for textile designers! This magazine is filled with inspiration and knowledge. You can subscribe online or get the magazine in the mail. A wealth of information.

www.fibreartsonline.com/fac/surface/index.htm

This Web site has a section called "surface design." Find out about associations and schools that teach printing on fabric and other surfaces.

www.fitnyc.edu

The Fashion Institute of Technology in New York has a surface/textile design program. Visit their Web site to learn more!

www.gradschools.com/programs/
fashion_craft_design.html
This site helps you find graduate
programs that teach fashion and textile
craft design close to where you live.

## BOOKS:

*Linoleum Block Printing,*
by Francis J. Kafka
This is an inexpensive investment. A
book filled with info and history about
block printing. The photos might be a
tad outdated, but it is filled with useful
information and techniques.

*Silk-Screen Printing for Artists and
Craftsmen,* by Mathilda V. Schwalbach
and James A. Schwalbach
Lots of inspiring photos and simple
hands-on instructions if you want to learn
more about this printing process! Love
this book, and it is not expensive.

## ACKNOWLEDGMENTS

This book would never had been made if it weren't for Nick and Tim.

Many, many thanks to our charming models: Nerissa, Ann, Lena, och Lena

Tack Kai

Thank you, ever so much, Jodi and Kate, for all your patience and support.

Tomo and Chiyo: keep making great things!

And a very special thank you to: Teo, Sig-Britt, and Alba

APPENDIX: STENCILS

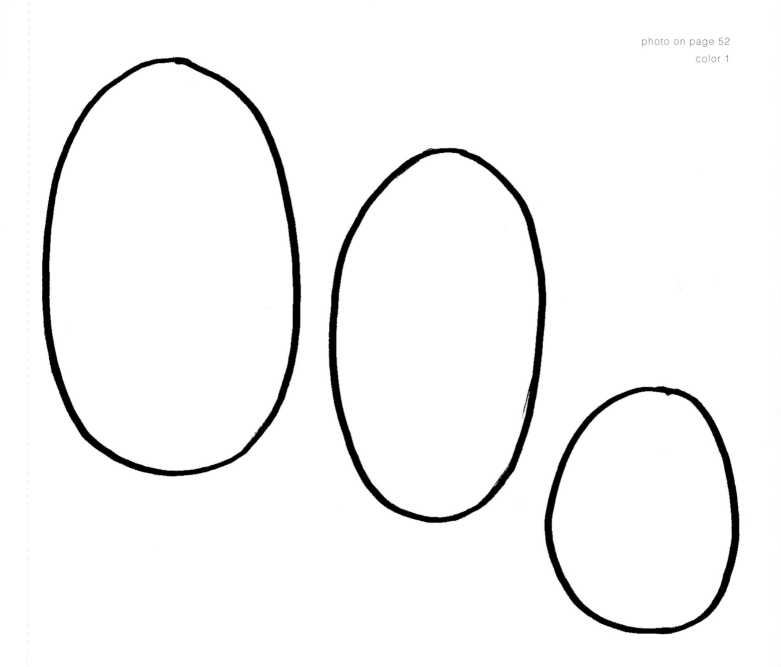

photos on pages
13, 53, and 55

photos on pages
50, 51, and 53